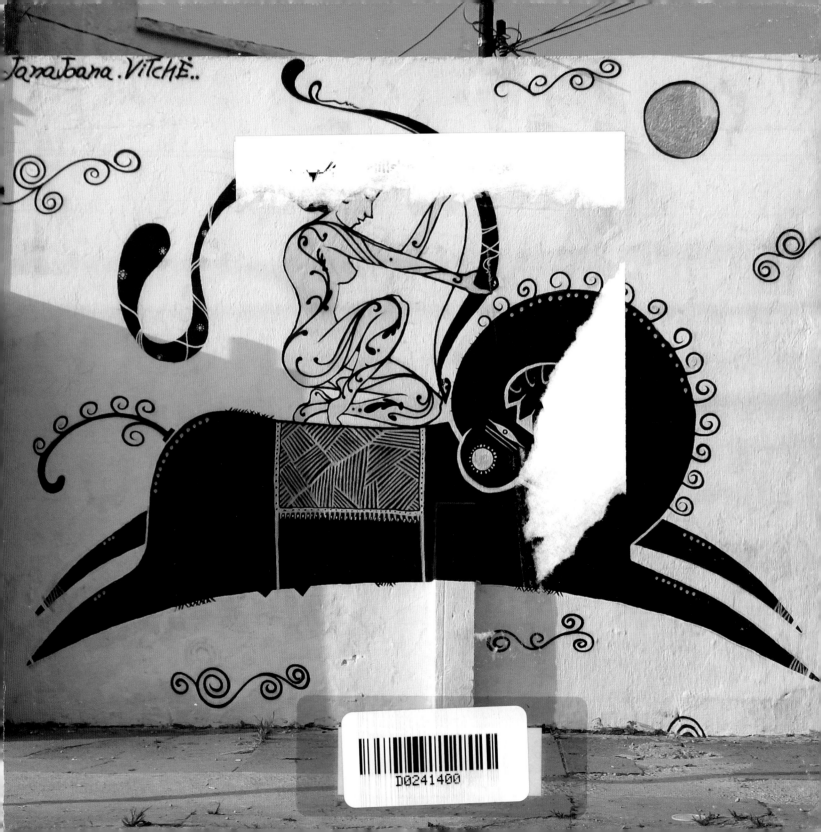

Janabana.VitChè..

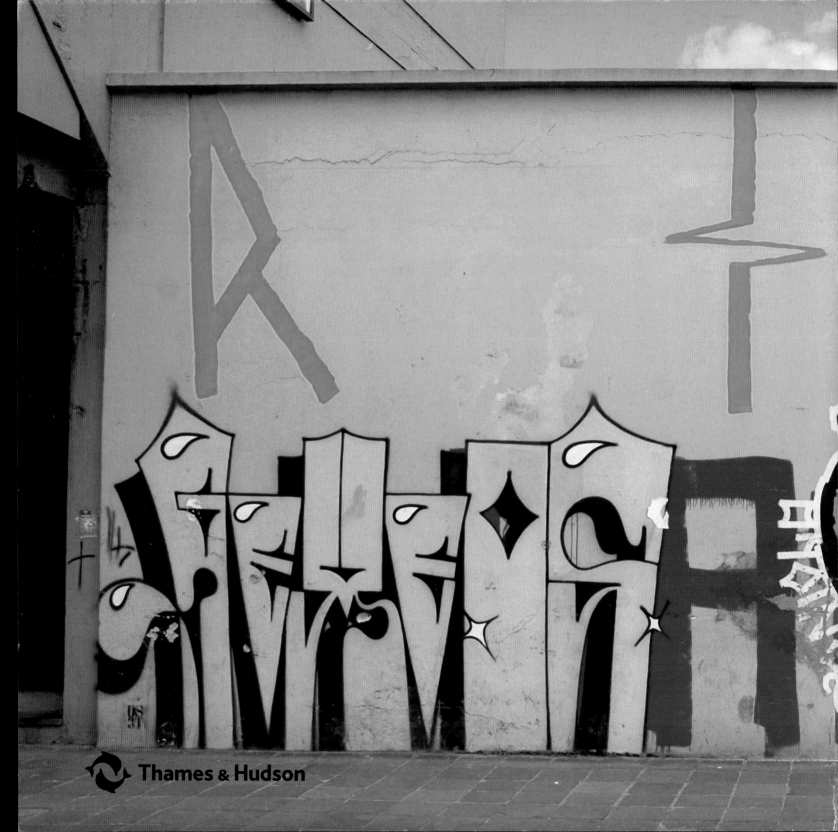

# graffiti brasil

**Tristan Manco** ◇ **Lost Art** ◇ **Caleb Neelon**

With over 300 colour illustrations

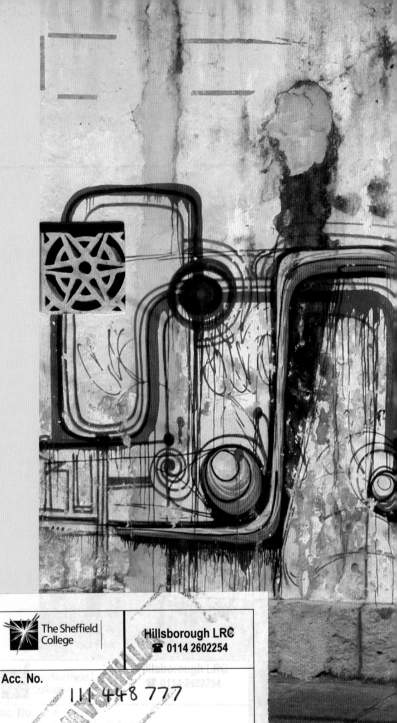

**Captions**

**Page 1** Jana Joana and Vitché, São Paulo, 2005 **Pages 2–3** Characters and letters by Os Gemeos and Nunca, Porto Alegre, 2004 **Pages 4–5** Kboco and Highraff, Olinda, 2004

**Acknowledgments**

**Tristan Manco:** Luis Manco, Jean Manco and Kerrianne Orriss. **Lost Art:** Louise Chin, Claudio (*grapixo*), Otavio, Gustavo, Carina, Zezão, Titifreak, Kiko, Lerdos, Agentes, Os Gemeos, Kboco, Baixo & Mariana (Choque Cultural), Albano Mendes, Dona Margarida, Paulo Gambale and Edu Mendes. **Caleb Neelon:** Meredith Alm, Allen Benedikt, Jessica Hoffmann Davis, Igor Dzierzanowski, Shepard Fairey, Roger Gastman, Cody Hudson, Albano Mendes, Steve Powers, Annie Silverman, Ellen Van Scoyoc, J. D. Wood, and the VL / OK and MSB teams and their families.

Thanks to the following people for their help: 9li, 86, Akeni, Rui Amaral, Anton, Asa, A.V. Crew, Herbert Baglione, Baixo, Base V, Binho, Boleta, Pete Bookham, Borrao, Clever Braga, Calma, Rafo Castro, César, Cimples, Ciro, Claudio, Coio, Renan Cruz, Dalata, Correio da Manha, Daze, Tony de Marco, Denys, Dinho, Dionr, Dois Mil, Donato, Ducontra, DV Crew, Exito d'Rua Crew, Fabio, Fefe, Fleshbeck Crew, Flip, Fred, Gaze, Gordo, Mateus Grimm, Gripe, Highraff, John Howard, Ira, Ise, Paulo Ito, Jey, Jana Joana, Geovaldo Jose, Kaleb, Kboco, Kerami, Joao Leao, Loomit, Loucos, Melton Magidson, Maionese, Mauro, Barry McGee, Daniel Melim, Albano Mendes, Nina Moraes, Mr Beam, Nação Crew, Adam Neate, Niggaz, Nina, Nois, Nunca, Onesto, Onio, Alexandre Órion, Os Gemeos, Pedra, Lucas Pexão, Phinok, Guilherme Pilla, Emerson Pingarilho, Plim, Ponotogr, Prozak, Pulga, Rim, San One, Sapo, Segue, SHN, Sino, Speto, Spit, Syen, Jorge Tavares, Tchais, Thesis, Tikka, Tinho, Tinico, Titi, Traços, Trampo, Marion Velasco, Vitché, Waleska, Wozy, Xerel, Yellow Dog and Zefix. Apologies to those artists we were unable to thank due to lack of space.

First published in the United Kingdom in 2005 by Thames & Hudson Ltd, 181A High Holborn, London WC1V 7QX

www.thamesandhudson.com

British Library Cataloguing-in-Publication Data
A catalogue record for this book is available from the British Library

ISBN-13: 978-0-500-28574-9
ISBN-10: 0-500-28574-8

Printed and bound in China by Hing Yip Printing

# Contents

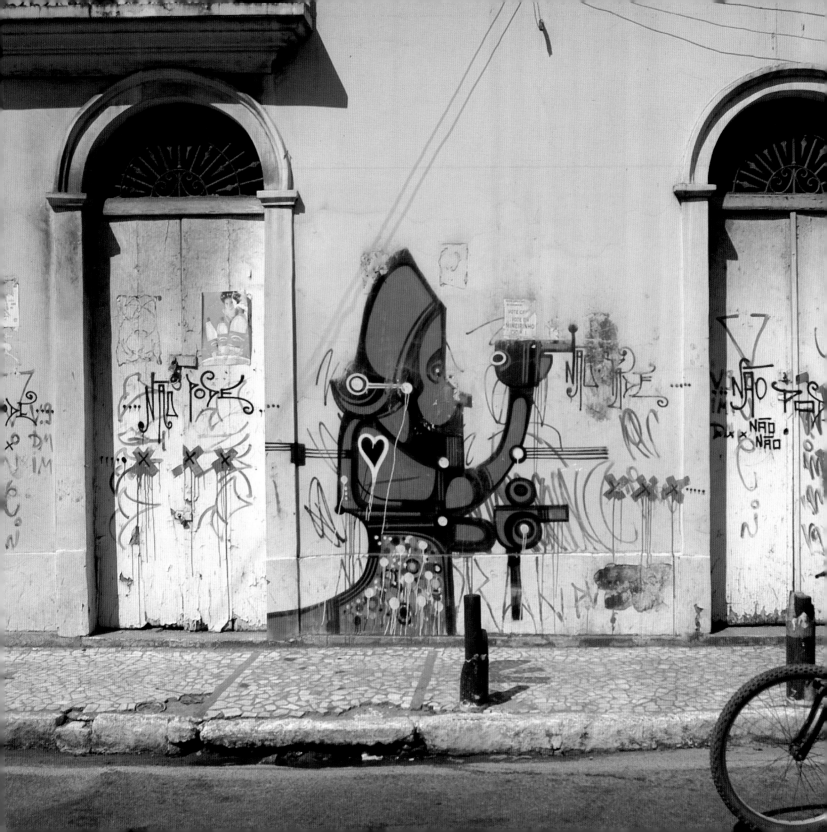

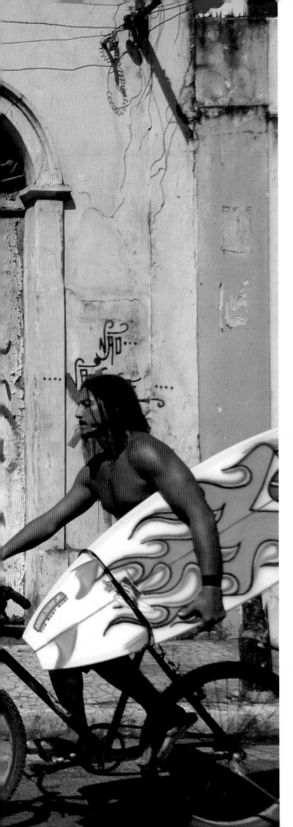

# Preface

From the streets of São Paulo to the boulevards of Rio de Janeiro, graffiti art flourishes in every conceivable space in Brazil's cities. It exists for just a brief moment in time before being lost forever in the city layers. In Brazil, graffiti can feel totally different from one city to the next. The focus inevitably falls on São Paulo, which is covered in graffiti and is unlike any other place on earth, but other cities such as Rio de Janeiro, Recife, Olinda, Belo Horizonte and Porto Alegre also have active scenes. Travelling through the Brazilian graffiti landscape, we have captured elusive creative moments from all over the country in the hope of preserving transient works.

Brazil boasts a unique and particularly rich graffiti scene, which in recent years has earned it an international reputation as *the* place to go for artistic inspiration. In the past Brazilian graffiti artists were influenced by the American and – to a lesser extent – European scenes, but it was difficult to obtain information about what was happening outside the country. This isolation generated new styles and techniques, and economic restrictions forced artists to adapt and improvise. The Internet has since facilitated Brazilian connections with the worldwide scene, but a whole new generation of graffiti artists is now emerging from Brazil with entirely fresh ideas, techniques and messages. *Graffiti Brasil* is a celebration of Brazil's artistic independence.

*Não Pode* (You Can't), Kboco, Olinda

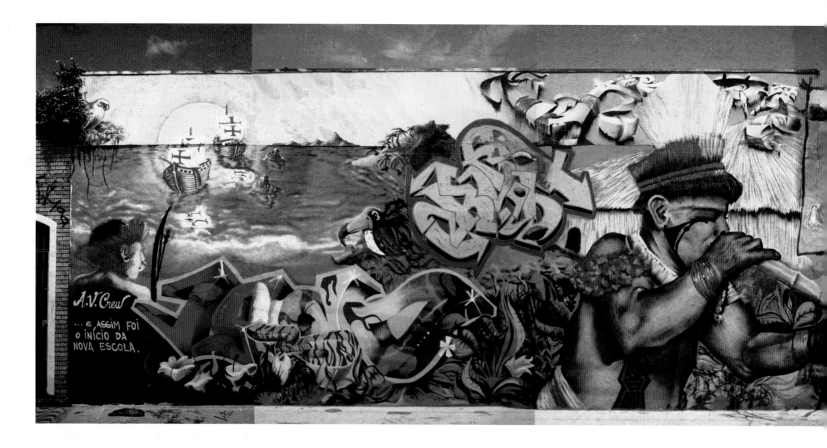

# Introduction

Around the world, Brazil holds a cult fascination. People wear T-shirts emblazoned with Brazil's striking green-and-yellow flag, not only because they like football, but also because they identify with the country and its culture. The word 'Brazil' conjures up intoxicating images and sounds of the rainforest, football stadiums, sultry bossa nova and raucous samba parades.

This idealized view of Brazil is part mythology, but the reality is even more compelling. Brazil is made up of the descendants of indigenous peoples, Portuguese colonists, their indentured African slaves, and later waves of Italian, Spanish, German and Russian immigrants. Japanese immigration began in 1908, and today São Paulo has the largest number of Japanese people outside of Japan. Brazil has the second largest black population in the world, having received more African slaves than any other colonial country from the mid-16th century onwards. This balance of influences has created a unique cultural recipe for Brazilian society and its artistic expression.

Brazil's problems of poverty and unemployment stand in stark contrast to the picture-postcard image of a tropical paradise. The epic struggles and conditions of the country's marginalized peoples over recent decades have been powerfully documented by Brazilian photographer Sebastião Salgado, whose published works brought their plight to international attention.

Despite being one of the largest economies in the world, Brazil has one of the most uneven distributions of income. Laws and taxes change frequently. This poses enormous challenges, but its people are resilient and are able to adapt to the ever-changing rules – a flexibility frequently referred to as *jogo de cintura*.

Brazil is wildly different from anywhere else in the world. It virtually equals the United States in size and feels more like a continent than a country. Its geography and nature are also special, boasting so many distinctive animals, plants and fruits endemic to Brazil that it feels like another planet.

Surrounded by Spanish-speaking Latin America, Brazil is the only South American country to have Portuguese as its first language. Its mix of indigenous

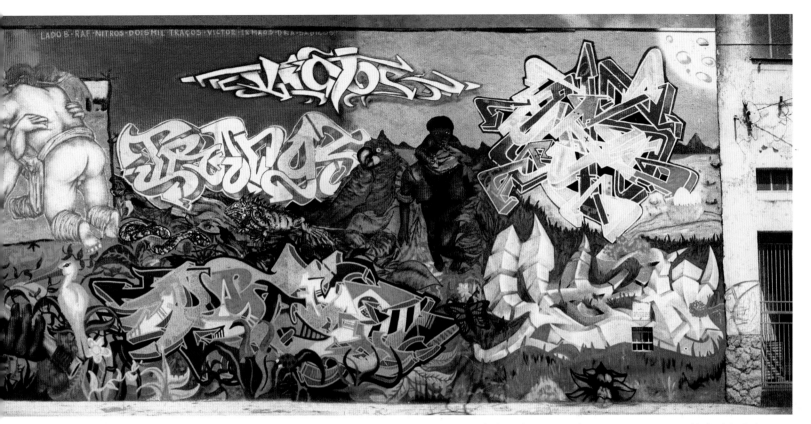

A.V. Crew (Lado B, Raf, Nitros, Dois Mil, Traços, Victor, Irmãos, DKA and Sadicos), São Paulo

and imported cultural influences has created a wealth of unique folk traditions in music, story-telling, arts and crafts.

While the Brazilian experience has created its own burgeoning graffiti scene, parallels are often drawn between the energy of São Paulo today and 1970s New York. For many years New York was seen as the global hub of graffiti styles, part of an alternative hip-hop culture, which was bursting out from its decaying neighbourhoods. Over the past decade, however, São Paulo has become the new shrine to graffiti. The innovation in Brazilian graffiti is reminiscent of those heady days of New York's graffiti boom, and artists all over the world are now looking to Brazil as a new source of inspiration.

Legendary New York graffiti artist Daze reflects on some of these comparisons:

'I first came to Brazil in March 2001 to collaborate with the Os Gemeos brothers on murals for a film project. I vaguely knew about the scene in São Paulo. What I knew was mostly from magazine publications and images on the Internet, but what I saw was enough to initially spark my curiosity.

'Nothing, however, could prepare me for the overall impact I experienced upon my arrival in São Paulo. I was immediately impressed, not only by the size, scale and density of the city, but also by the variety of graffiti styles within this sprawling metropolis, which left me in awe of their sheer will and determination to "get up".

'The entire culture of hip-hop, graff included, was fuelled by a do-it-yourself attitude. There was no money behind anything that was being done at that point, yet there was an incredible amount of innovation at every level of the game.

'As a subway writer from the New York era, I connected with what writers in Brazil were doing. Instead of waiting for opportunities, recognition and support to arrive, they were taking matters into their own hands and producing some of the best work in the graffiti scene worldwide.

'Since then I've made it my own personal mission to paint and collaborate with writers from Brazil. As important as it is for them to collaborate with writers from abroad, it's just as vital for me. I'm not sure

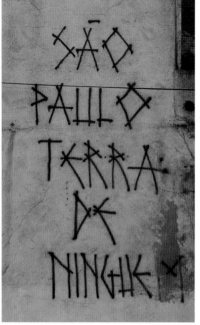

Os Gemeos, São Paulo

*Sopa de letrinhas* (alphabet soup), São Paulo

Ira, Maracana Stadium, Rio, 2004

what direction all this is going in, or what will develop, but I'm enjoying the ride.'

Brazil's chronic poverty is far worse than that of 1970s New York, but such conditions have fuelled a vibrant graffiti culture in both. The most noticeable style of writing in São Paulo and the country's other major cities is *pichação*, a form of tagging that originates from its poorer neighbourhoods.

*Pichadores*, the masters of this art, risk life and limb making their mark on the city, from the tallest buildings to the undersides of motorway flyovers. With an almost blanket coverage of the city, this raw and elongated calligraphy has been developed by many hands over time – a folkloric vandalism and an urban sport for the disenfranchised.

On the outskirts of Brazil's sprawling cities, concrete stretches for as far as the eye can see, taking the place of parks and other amenities. *Pichação* offers young Brazilian writers a chance at fame, enabling them to publicize their names in a similar way to the brands they see on advertising hoardings.

Through its cities' walls, we can gain an insight into Brazilian life – where extremes live side-by-side. The intense vandalism of *pichação* tags stands alongside some of the most intricate and poetic works of art, painted in the name of graffiti. From chaos to colourful artistic experimentation, graffiti is both a manifestation of social issues and an artistic reaction to them, and it has something to offer at many levels, both socially and culturally. In Rio de Janeiro's shanty-town *favelas*, for example, graffiti is just one part of a *cultura de rua* (street culture) that includes hip-hop, funk and samba music, dance and painting. This alternative culture provides a voice for a systematically neglected section of society, as well as artistic forms that offer both skills and opportunities for success.

All city spaces are up for grabs in Brazil. Apart from private and public buildings, any wall is a potential site for political publicity or business advertising. Much of this signage is hand-painted and unauthorized, and graffiti artists do not find it hard to claim their own space.

Os Gemeos summed up this situation when they painted 'São Paulo – No Man's Land' around the city in *pichação* lettering. São Paulo and many other cities, expanding without urban planning, are a patchwork of decay and construction that is the undercoat for graffiti artists' interventions. Before an election, however, the city is whitewashed, primarily to impress the electorate, but also to provide a blank canvas for new election murals. This also gives graffiti artists a chance to repaint spots and begin the whole process again.

Graffiti in Brazil is interlinked with its own history and the society, history and culture of the country itself. This is a constant theme in *Graffiti Brasil*, and it is from this perspective that the book develops. These links are what make Brazilian graffiti so extraordinary.

Ciro, São Paulo

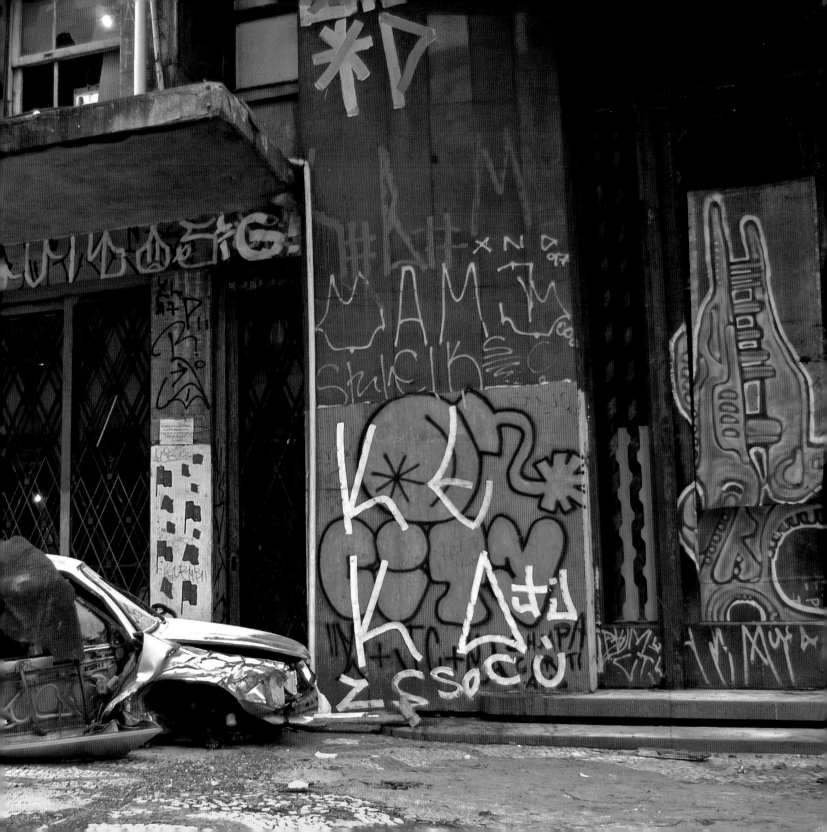

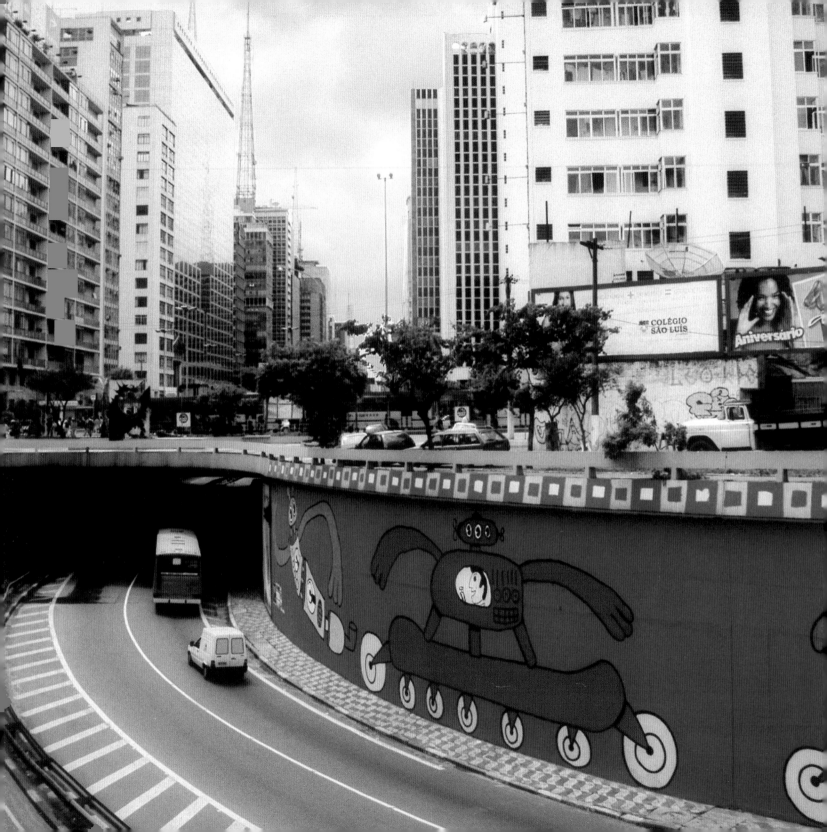

# History

Brazil has a graffiti heritage dating back to indigenous Amazonian rock carvings, but its modern tradition only began over the last fifty years. With its roots in protest, graffiti provided a voice of opposition to Brazil's social and economic problems. In the mid-20th century, a growing urban population expressed their opinions through 'wall writings' – political messages written with tar. By the 1940s and '50s, these political writings, known as *pichação*, were commonplace. They were often written in response to the slogans painted by political parties across the streets.

Graffiti during the 1960s was influenced both by politics and by the new movements in art and music. Protest messages hit street corners as an initial reaction to the military overthrow of Brazil's democratic government in 1964. After the coup, however, graffiti became too dangerous to be a widespread activity. It was more difficult to suppress the music scene, which had an enormous influence on popular culture. After the *coup d'etat*, bossa nova musicians from Rio de Janeiro began to write protest songs, and, as bossa nova evolved into other forms such as MPB (*Música Popular Brasileira*), it began to attract a mass following and hold increasing sway through televised concerts. By the end of the 1960s a new Tropicalia movement had developed from MPB, blending rock, pop and traditional music, often with a political dimension. Some of its most famous artists, including Caetano Veloso and Gilberto Gil, spent time in both jail and exile for performing and writing their popular and revolutionary anthems. Much like protest graffiti, music was a public space where the voices of the silent majority could be heard. The lyrics from some of these songs also became slogans for graffiti at the time.

It was not until the mid-1970s that Brazilian graffiti became more animated. In 1977 pro-democracy movements once again took to the streets of São Paulo and other industrial cities in large public demonstrations. Although military rule did not end until 1985, popular opposition during the '70s was becoming more open. As protesters reclaimed public space, artists began to use the city spaces for political and cultural expression. This led to an explosion of graffiti and urban interventions in the larger cities. *Pichação* 'wall writings' became bolder and more irreverent, and their use of

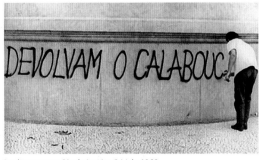

Student protest, Rio de Janeiro, 24 July 1968

Rui Amaral, Buraco da Paulista, São Paulo

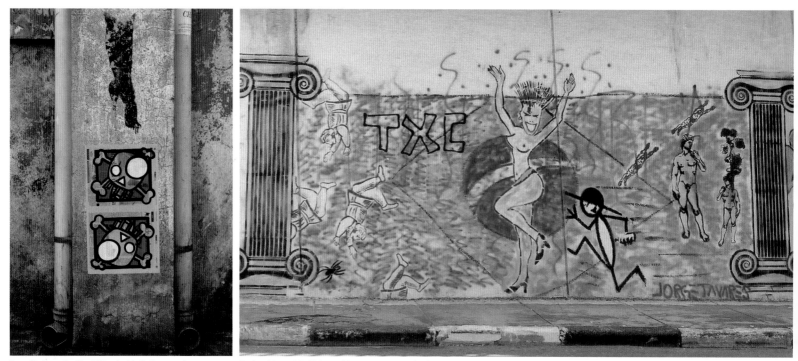

Stencilled boot by Alex Vallauri with skull posters by SHN, São Paulo

National Day of Graffiti mural by Jorge Tavares and others, São Paulo

word play led many people to describe them as urban poetry. By contrast, a new movement of image-based, multicoloured graffiti began to develop.

One of the first *grafiteiros* to paint on the streets of São Paulo was Ethiopian-born artist Alex Vallauri, who became a naturalized Brazilian. In 1978, inspired by the writings of the *pichadores*, he began to express himself on the streets through spray-painted stencils. Soon people began to notice his first image, a black boot, on street corners all over the city. He continued to stencil iconic images across São Paulo, including gloves, cupids and devils.

Through Vallauri's work, stencilled graffiti became hugely popular, and soon many other artists were adopting the technique. Although not as well documented as the stencil graffiti of Paris or New York, São Paulo's scene was extensive and, as a mass movement, may have even pre-dated its European and

North American counterparts. Between 1982 and 1983 Vallauri took his brand of graffiti to New York, taking part in shows and stencilling the famous Danceteria nightclub. He died of AIDS on 27 March 1987, which subsequently became the National Day of Graffiti in Brazil. Other renowned stencil artists include Hudnilson Jr, whose work relates to images of the body, Maurício Villaça, a key figure in this new graffiti movement who died of AIDS in 1993, and Jorge Tavares and Celso Gitahy, who still paint stencils today.

During the stencil craze, many artists also began painting figures and scenes freehand with latex and spray-paint. Much of this new 'free art' was painted in an exuberant, naive way that reflected the graphic style of the late 1970s and early '80s era. One of the pioneers of street painting in São Paulo was John Howard, an American artist who had moved from San Francisco to Brazil. Howard was a great believer in graffiti as an

ephemeral art and became a prolific painter on the streets. Among other things, he painted over six hundred telephone poles throughout São Paulo with his colourful images. People who rarely went to galleries or museums enjoyed the vitality and immediacy of his work on their own doorstep.

When Howard began his outdoor painting in 1978, graffiti was less widespread and did not incorporate hand-painted images. Some years later he was offered a job teaching graffiti to kids, many of whom were *pichadores*. He discovered that, although they painted *pichação* for fame, they found the idea of painting images equally stimulating. In an interview for a San Francisco newspaper he recounted: 'In São Paulo you always had the feeling that there was no centre, no history…a city landscape with few trees, no parks and miles of fortress-like walls. There were millions of kids with no access to libraries or museums,

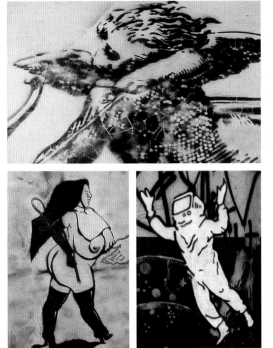

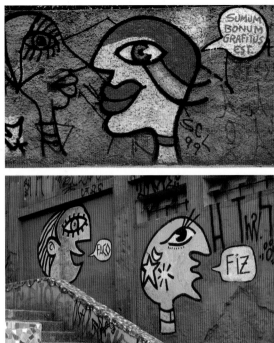

Top Maurício Villaça **Bottom left** Jorge Tavares
**Bottom right** Maurício Villaça

John Howard

Rui Amaral

nothing. But street art introduced the possibility. The kids realized, "Hey, I can do something". The city became theirs.'

Soon other artists became inspired by Howard's work. One of the first was Rui Amaral, who began to paint iconic characters alongside Howard. They painted together, often quite brazenly, in some of São Paulo's busiest spots. Today, Amaral is still an active painter and an ambassador for graffiti in the city through his involvement in numerous community and social painting projects. Artist Keith Haring also influenced Amaral and others from this generation. Haring had spent some time in Brazil, often visiting Rio during the carnival with friend and fellow artist Kenny Scharf.

This was an age of excitement and optimism for a growing group of artists who risked arrest to beautify the cityscape with their temporary art. It was also a time of experimentation. The arts group Tupinãodá

painted labyrinths using rollers and latex paint. Other artists, such as 3NÓS3, Rafael França and Mario Ramiro, specialized in urban interventions, including illegal sculptures on viaducts and monuments, giant stencils on roads, and miles of coloured plastic strips that brought traffic to a halt. At first this new graffiti was seen as an oppositional and unsanctioned form of expression, but as the media and the city began to establish their first relationships with graffiti, this view became more complex.

In his 1995 article, 'Resistance and Appropriation in Brazil: How the Media and Official Culture Institutionalized São Paulo's Grafite', Neil E. Schlecht observed graffiti's transition from a marginal culture to an accepted art form. He noted that the media's coverage of graffiti at the end of the 1970s tended to use phrases such as 'visual pollution', but as more graffiti began to appear on the streets some

commentators began to view it as a 'proof of democracy and freedom, after so many years of repression'. By the early 1980s graffiti had become more mainstream, and its practitioners began to be profiled in the media as graffiti celebrities. As if to legitimize the scene, *Veja* magazine reported that John Lydon, ex-Johnny Rotten of the Sex Pistols, had said in an interview that the most impressive sight in Brazil was the graffiti of São Paulo.

Until the mid-1980s the Brazilian graffiti scene was very much home-grown and divided into *grafite* (graffiti murals) and *pichação*. While some artistic influences had come from abroad, the culture itself was of its own making. Into this mix came a new force – hip-hop and the New York style of graffiti. In much the same way that hip-hop culture spread around the world, it was films such as *Beat Street* that captured the imagination of many soon-to-be breakdancers and graffiti artists.

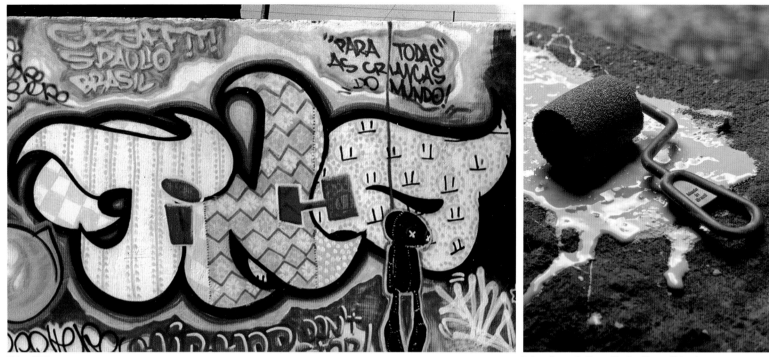

Tinho, 1996

Paint roller, typically used by Brazilian graffiti artists

Hip-hop flourished naturally in Brazil. This may have been due to the country's own African roots or the ease with which Brazilians related to the aspirations and expressions of its African–American pioneers. The basic tenets of hip-hop – breaking, rapping, scratching and graffiti painting – were taken seriously, and competitions in all these areas continue to draw in huge numbers of people.

Many of today's well-known artists were young teenagers just as the hip-hop movement was finding a new home in Brazil. Artists such as Herbert Baglione, Os Gemeos, Tinho, Binho, Speto and Onesto, to name a few, were drawn to this new hip-hop scene around the same time. For a lot of these artists, it was the music and breakdancing that provided a first step into graffiti. Os Gemeos, Vitché and others were breakdancers before they were drawn to the graffiti aspect of hip-hop culture.

Not surprisingly, early hip-hop-style pieces were basic at first, as artists tried to emulate the complicated lettering styles they had seen fleetingly in a film or a magazine. Unlike Europe or the US, books such as *Subway Art* were harder to obtain, as were spray-paints and caps. To make up for lost time and learn what they could about letter styles and tags, Brazilian kids had to be inventive. Sometimes painters only had an impression of New York graffiti and were not clear on the details.

In São Paulo and other cities, b-boys would congregate at jams, making contacts with other breakers, artists or musicians. By 1991 hip-hop and graffiti had become noticeably stronger movements, and people would travel to bigger events in different cities. Hip-hop music was now being made in Portuguese, and the graffiti styles, while still influenced by New York, were of a higher quality.

Hip-hop graffiti writers gravitated to the same spots as the earlier street painters, such as Buraco da Paulista (the Paulista Pit), the underpass leading to Avenida Paulista (São Paulo's equivalent of Wall Street and Fifth Avenue in one). The Buraco was the first area in which graffiti was allowed officially thanks to the street artists of the early '80s. In places such as these, a younger generation of graffiti writers began to paint side-by-side with the more established first generation of street artists.

With the benefit of hindsight, it is easy to see the influences of stencil art and street art murals on today's graffiti culture. During the early 1990s, however, the street artists and the new graffiti writers must have seemed worlds apart. Accepted by the media and the government, graffiti muralists such as Rui Amaral could secure financial support for large projects, whereas the younger artists did not yet have this backing and were

Barry McGee exhibition catalogue, Museu Lasar Segall, São Paulo, 1993

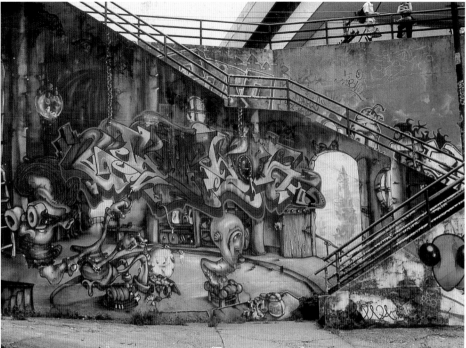

Os Gemeos mural, São Paulo, 1997

restricted to smaller productions. Gradually this balance shifted, as many of the original fêted street artists moved away from graffiti, and the hip-hop style became mainstream and applauded.

The 1990s were a period of development and change for hip-hop graffiti around the world. The New York style was alive and well, but in Brazil, as elsewhere, artists were finding their own particular ways of painting rather than sticking to the 'old-school' styles. Graffiti techniques tended to be different in Brazil (see page 21), but there was a natural desire to personalize graffiti and create an individual style.

An important chapter in the history of graffiti was Barry McGee's (aka Twist) visit to Brazil. Having graduated from the art institute of San Francisco in 1991, McGee was making a name for himself as an artist both on and off the street. He was known for his hand-style lettering, but it was his two-coloured

characters that attracted a wider audience. San Francisco has a large homeless population, and these day-to-day characters became the inspiration for his graffiti.

In 1993 Barry McGee won funding for an artist's residency in São Paulo and the chance to travel north to Bahia. His experiences in a small town called São Cristovão had a profound influence on his work. While visiting a local church, he was inspired by the many votive offerings that had been made by generations of pilgrims. Thousands of small woodcarvings, known as ex-votos, or *milagres*, filled the church along with clusters of framed pictures, all representing a life or an individual story. He was inspired by the spirit and simplicity of these offerings and the powerful effect they evoked together. In his subsequent work he began to frame his own sketches and paintings in a haphazard fashion that was reminiscent of the offerings at São

Cristovão. Fragments of urban and everyday life were already a theme in his work, both in the images he chose to paint and the materials he found and used, but this Brazilian experience acted as a catalyst. Many Brazilian graffiti artists mention McGee's work as an influence today, not only because he took inspiration from Brazilian spirituality and aesthetics, but also for the paintings and the contacts he made there.

During his time in São Paulo, McGee often painted his figures on the streets and became acquainted with the work of other graffiti artists. He got to know Os Gemeos, which proved an influential encounter for all concerned. They learned much from each other, not only in the way they painted, but also in their artistic approach. Through his own work and a stash of graffiti photographs and magazines, McGee showed Os Gemeos a new world, of which they had previously been unaware. At this time the twins were only

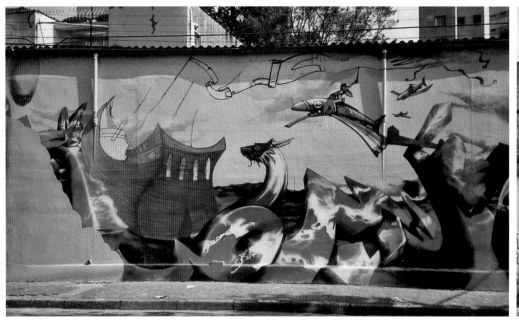

Loomit and Vitché, São Paulo, 1999

Vitché, Os Gemeos and Jon 156, São Paulo, 1999

nineteen years old. Their work still had a traditional New York style but it was of a high quality considering Brazil's isolation from the rest of the graffiti world. Barry McGee exhibited at the Museu Lasar Segall in São Paulo before heading back to San Francisco. He took with him many influences from Brazilian culture and Os Gemeos. He also left an indefinable legacy, which encouraged artists to take inspiration from their own experiences, rather than following prescribed styles, and to feel the freedom to explore their own culture as Brazilians.

The following years were particularly crucial in creating Brazil's current distinctive graffiti. This phase was characterized by developments by Brazilian artists and more exposure to the international scene. Brazil's relative remoteness in the global graffiti arena seems to have been a virtue for its artists, prompting them to look to their individual ideas and environment to create their own visual language.

By 1997 Brazil had many of its own graffiti magazines and videos. Most were self-published, such

as *72diesel*, *Dest* and *Fiz*. Graffiti jams were bringing together artists from across Brazil, and, as a result, there was more awareness of what was happening nationally. At the same time more influences were filtering in from abroad through international magazines, books and the Internet.

McGee told *12 Oz Prophet* magazine editor Allen Benedikt/Raven about the Brazilian scene, and in 1997 he and Sonik travelled to São Paulo to visit Os Gemeos. The resulting 1998 issue of *12 Oz Prophet* introduced the Brazilian scene to graffiti writers throughout North America and Europe, which catapulted São Paulo to the top of many writers' destination wish lists. In the years that followed, other artists such as Doze, Jon 156 and Emuse started to travel to Brazil to paint.

Naturally, with all these developments, communications between Brazilian painters and artists abroad became more common. One of the major collaborative projects of 2001 involved Loomit, Daim and Tasek from Germany and Brazil's very own

Nina, Herbert Baglione, Vitché and Os Gemeos. Together, they produced a mural of gigantic proportions on 23 de Maio Avenue in São Paulo. Brazil had become the place to paint and a beacon for original talent and craftsmanship.

In today's vibrant graffiti scene, artists continue to play their part in Brazil's exceptional graffiti story while taking their own individual paths. Styles continue to evolve, with writers who have been mixing *pichação* and graffiti to make *grapixo* (a hybrid lettering style combining graffiti and *pichação*). Street artists have been reviving stencils and older poster traditions. The act of writing graffiti on a wall, which was originally politically motivated, continues today with that same spirit of defiance. Resources are stretched, and you risk imprisonment, police brutality, humiliation and much worse if you do graffiti outside the tolerated areas. Still no one seems deterred, as graffiti here has become a vital lifestyle, a bond between friends and an essential freedom of expression.

Os Gemeos, São Paulo

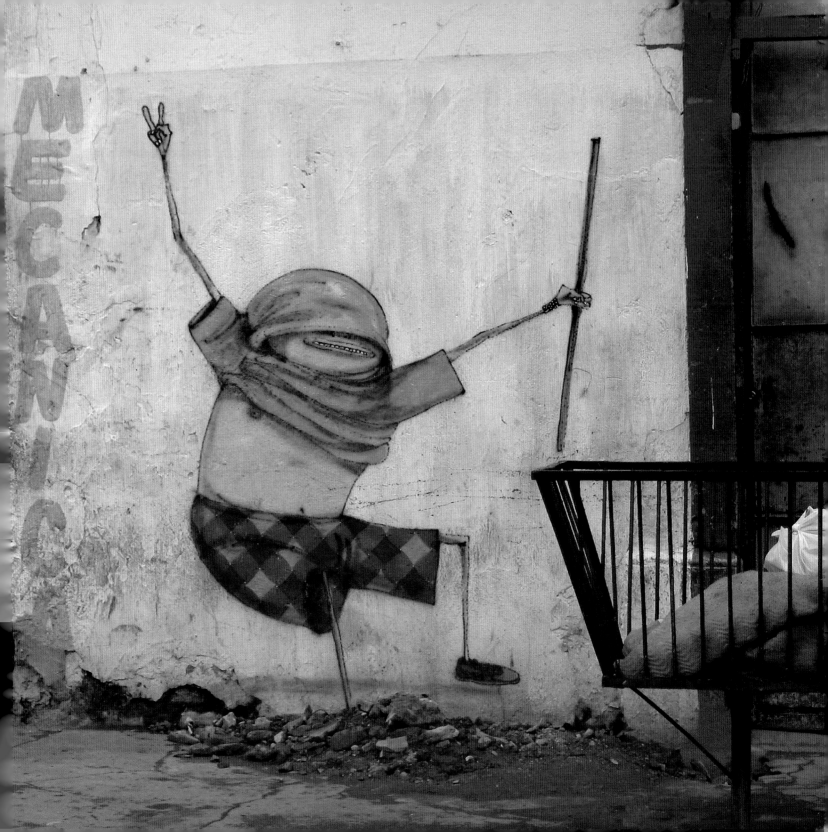

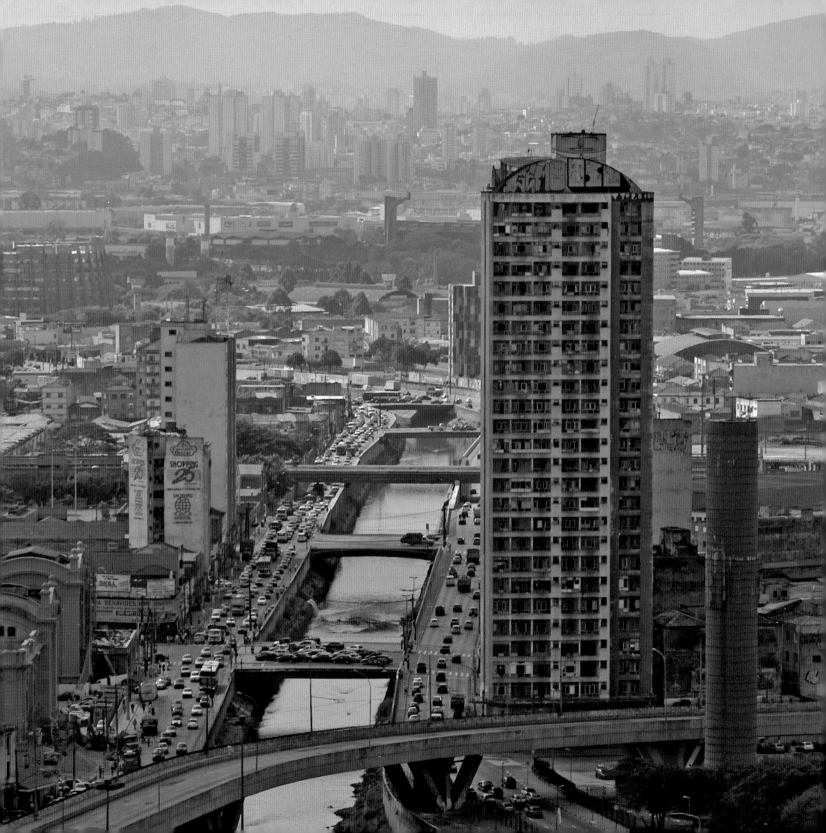

# Techniques

There's Always a Way: The Techniques, Processes and Spaces of Brazilian Street Painting

Street arts in Brazil have long been marked by improvisation and boundary-crossing, whether stencilling, *pichação* or hip-hop graffiti. The different schools of street painting are generally respectful of each other, and they share a mutual understanding not to paint over one another. Brazilian street art – and artful vandalism – were booming practices long before the advent of hip-hop, and the various styles and methods have borrowed freely from one another since then.

It is a part of the Brazilian national character to be resourceful and adaptive. Brazilian poet Oswald de Andrade termed this peculiarly Brazilian quality *antropofagia* (cannibalism). According to Andrade's 1928 manifesto, since some of Brazil's indigenous inhabitants had practised cannibalism, the trait was still present in the Brazilian national character, just like the bloodlines of the cannibal race. Andrade's *antropofagia* meant the gobbling up of the cultures of the world – if you see something you fancy, eat what you like and leave the carcass. The spread of the hip-hop movement is a fine case in point, with Brazilian young people

picking at a culture that had sprung from New York's leftover spaces and materials.

In Western Europe, as well as Japan and Australia, young people had the resources to import hip-hop culture with few, if any, modifications from what they saw in movies such as *Style Wars* and *Wild Style*. Young breakdancers in these First-World nations wore adidas, DJs used Technics 1200 turntables, and graffiti writers spray-painted trains. Brazilian hip-hoppers, on the other hand, tended to adapt rather than adopt. Breakdancers retrofitted their backspins into the endemic dance and martial art of *capoeira*. DJs did their best with what they had in the way of records and record players, but also incorporated samba beats and refrain patterns from the carnival samba school singing and chanting. And graffiti writers generally ignored trains and concentrated on developing a mixed-media approach to painting prominent street spots, alternating between affordable latex paint and more prohibitively expensive aerosols.

Some of these improvisations were due to a lack of resources, while others, such as the *capoeira*-infused

breakdancing and latex graffiti work, were due to the presence of pre-existing cultural resources on to which hip-hop mapped neatly. From hip-hop's buffet table, some facets were quickly gobbled up, while others were hardly touched.

The force behind the boom of graffiti in Brazil is its most reviled and prolific incarnation – the unabashedly vandalistic and territorial *pichação*. Endemic to Brazil and yet ubiquitous within its major cities, *pichação* is a name-based vandalism movement so prolific and aggressive as to make other graffiti seem a gentle crime. The visceral and typographic beauty of *pichação* is at times a tough sell even to graffiti aficionados, but anyone painting in the streets of Brazil must give it a tip of the hat, for it certainly makes other street artwork, rudely illegal or otherwise, appear a generous community service in comparison. Graffiti is of course illegal in Brazil, but São Paulo and Rio de Janeiro may be the only cities on earth where cops can accost you for doing a two-coloured throwup and you have a chance of getting away with it by saying, 'Hey, it's not that awful *pichação* stuff!'

Rooftop by Os Gemeos and Ise, São Paulo, 2004

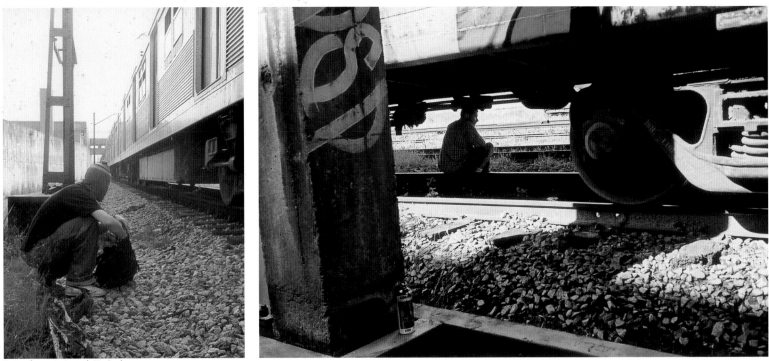

Scenes from a train yard, São Paulo

# How It Gets Done: A Sunday Story

In Brazil, whatever your crime of choice, Sunday is the day to do it. There are few people – and few police – out in the streets. City walls become open targets, and any structure without a guard is fair game if you're good at talking your way out of trouble. It doesn't mean that you're totally in the clear, but you're free to do a lot more. Going out to paint on Sundays is a tradition in Brazil, called the *rolê*, or 'roll'.

Some friends and I bundled off to the freight train yard one sunny Sunday morning to see if we might get lucky and paint a few old boxcars. The yard was beautiful to walk through, with dozens of these ancient freight cars, weathered and rusted to a beautiful patina and covered with *pichação*. The ground was soft and covered in yellow sulphur pellets that gave the whole yard the distinct smell of rotten eggs. It was great.

We noticed a bunch of young kids hanging out in the distance, painting and being loud. Not wanting to risk them coming over and blowing our cover, we decided to come back later. Freight yards are never a safe place to be in São Paulo, and police, should they come, may assume that you're stealing freight cargo, shoot first, and ask questions later – never mind the unsavoury characters that actually are there to rob the place. You can get away with a lot on a Sunday in Brazil, but that would be pushing it a bit too far. We took off.

We headed over to an abandoned factory, snuck in through a hole in the fence, and got to work. After a spell of frenetic painting, I paused and looked around behind me. The scene felt cinematic, an eerie pause in battle. We were standing in the bright subtropical sun, painting in a wide and overgrown vacant lot filled with

vivid safety purple delivery trucks and Volkswagen minibuses that in past lives delivered garlic to market. The sun beat down on us, and the grass that filled in the narrow spaces between the tightly packed trucks was a vibrant green. A dozen of São Paulo's younger writers had somehow heard word that we would be there painting and showed up to watch and paint a little as well.

Suddenly, everyone began yelling and packing up their paint. I soon found myself last in line to escape, with kids scampering in every direction over barbed fences and the rooftops of trucks, everyone pushing and shoving. I turned around just in time to see a big, strong man swing a three-foot lead pipe down on to my head. Screaming 'rapido, rapido!' I pushed through the jagged hole in the corrugated metal fence and

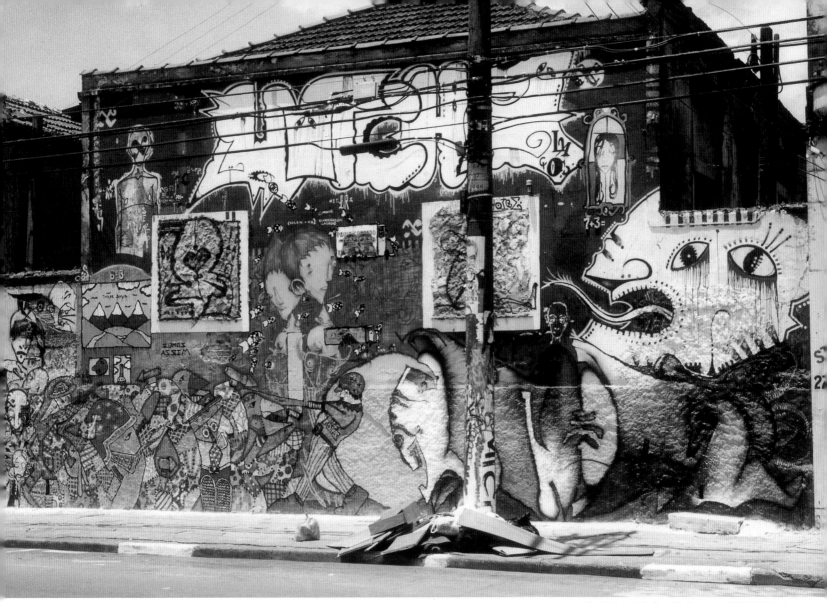

Sonik, Herbert Baglione, Os Gemeos and Vitché, São Paulo

joined my friends, who were charging top speed down the sun-languid Sunday street and breathing heavily.

When you're hit on the head, you get tired, but you shouldn't go to sleep because you can fall unconscious, and worse things can then happen. Being good boy scouts, however grouchy, we decided to keep me awake by painting something more complete. My friends found a large wall on a main street, part of an abandoned property.

We had been painting for a half-hour when a man walked by and asked, 'You guys painting the wall?'

'Yep,' my friends answered.

The man then said, 'It's my building.'

'Oh, word? There's no problem, is there?'

'Nope. Go all the way up, do the whole two-storey height of it, and paint right over my "for sale" signs if you want. I like what you guys are doing. Take your time and have fun.'

We never did make it back to that freight yard.

CALEB NEELON

# Diplomacy: A Sunday with Santos

The Brazilian word for shanty town is *favela*. They are not ghettos, really. *Favelas* fill in the city's disused spaces, brimming with life and activity until a developer decides there is money to be raised in their razing. Housing projects, icons of poverty in America's ghettos, would be luxurious in comparison to *favelas*. Rather unlike a housing project, in a *favela* housing is improvised by its residents.

One Sunday, some friends and I wandered the on and off ramps of highway interchanges, looking for a suitable wall. Under and around these interchanges was a small *favela* next to a wall, which we decided to paint. The walls and roof of the adjacent house were fashioned out of several discarded pale green doors. The man living there saw us milling around and came out, followed shyly by two lovely little girls, obviously his daughters.

He introduced himself as Santos, adding it was fine if we painted the wall next to his house, then offering the side of his shanty as well. We got to work. I took a break to wait for some paint to dry and chatted with him a bit. He told us his story— one full of financial hardship – and introduced his daughters, Caroline and Priscilla. Caroline was ten years old, wearing a dark floral dress and shyly smiling and chewing her fingertip as she watched us paint. Priscilla was four and hopping around us in her underwear with a big infectious grin. Santos then asked me for some money. Our group had nearly finished painting, so I pretended that I hadn't heard his last request, and hastily wrapped up my piece. As we packed up and took photos of the completed pieces, I asked Santos if he liked what we did. I also had some money in my palm to give to him, but he couldn't see it yet.

'I'm gonna paint over your artwork with whitewash,' said Santos.

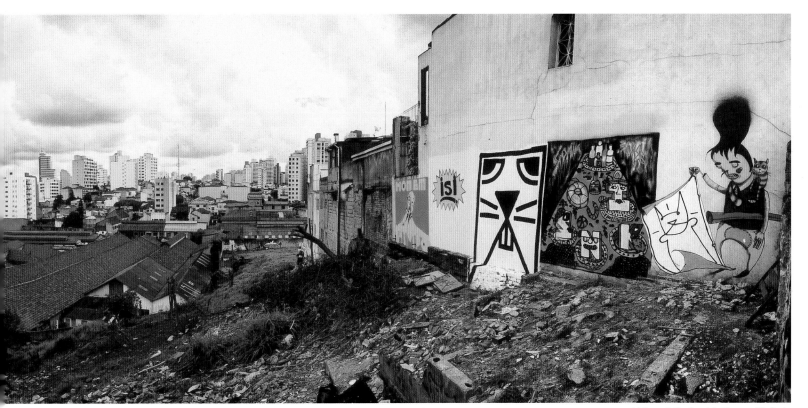

Isi, Keramik, Sonik and Os Gemeos, São Paulo

'Why?!' I asked.

'Because I asked you for a couple of bucks, and you didn't give me anything.'

'And you would rather spend time and money to destroy what we did than enjoy it as a gift to you?'

Santos looked down and mumbled something I couldn't understand.

I continued, 'Look, I know you can't eat paintings, so I have ten bucks for you. Here. Now, do you like the paintings any better?'

Santos mumbled something I couldn't understand. We saw some police in the distance and left.

Santos might have been able to get an honest job. But that honest job would mean something along the lines of sweeping filth in the streets for pay so low that he probably couldn't even afford to move his family out of the *favelas*. At least now he has time to see his daughters grow up, if little else.

My friends scolded me for giving money to Santos. They said that he probably wouldn't buy anything except alcohol, and that it also makes their job harder when street people start expecting graffiti writers to give them money. I could understand the latter part, certainly. But it is hard to blame Santos for asking,

even demanding: in that desolate part of town we might have been the wealthiest people to walk by all day. However nice it was to have a brightly redecorated neighbourhood, in a certain inescapable light it only underscored the fact that our small group of graffiti writers, in this case Brazilian, German and American, could afford to give things to his daughters that he couldn't.

CALEB NEELON

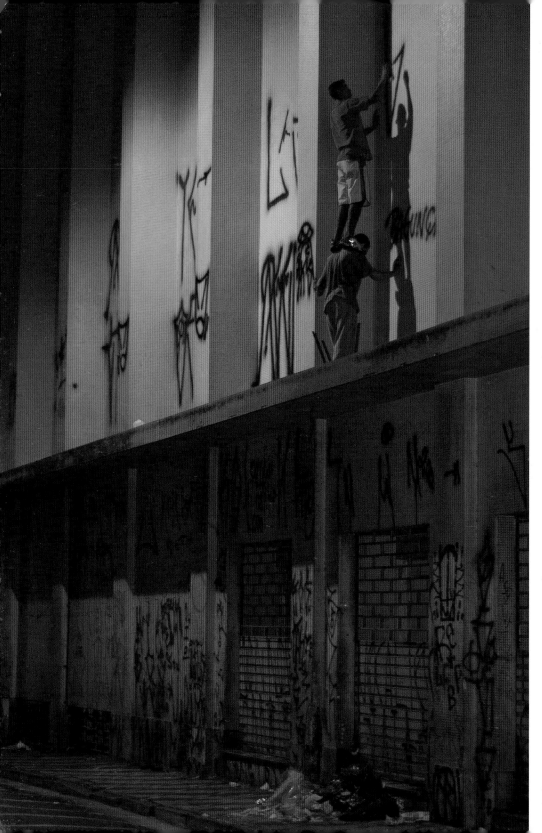

# Pichação

For years, the cure for the inner-city blues in São Paulo has been to write all over it with spray-paint or 3-inch rollers and a bucket of latex paint. In the 1960s people wrote political messages in the streets. The media called the writings *pichação*, pronounced 'pee-sha-sow'. *Piche* is Portuguese for 'tar', and *pichação* initially referred to markings made with it. In the 1970s *pichação* almost died away, except for an elderly man who wrote 'Cão Fila Km 26' ('Pit Bull Farm, 26 kilometres thataway', sort of) all over the place. In the early 1980s a handful of kids brought it back, trading in political slogans for names, both their own and those of their crews. *Pichação*'s beginnings had nothing to do with the worldwide explosion of graffiti in the spirit of what was done on the New York subways. It was a totally independent phenomenon, and remains so. In the early 1980s articles appeared in São Paulo newspapers about a young fellow who wrote the name

*Pichadores* in action, São Paulo, 2005

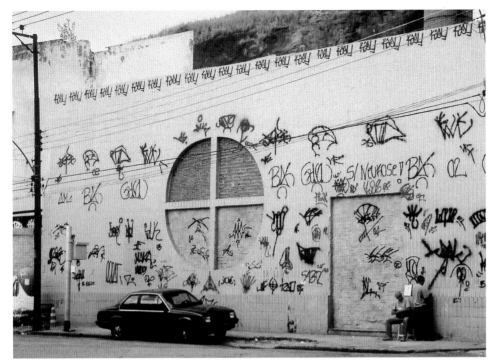

Rio de Janeiro, 2004

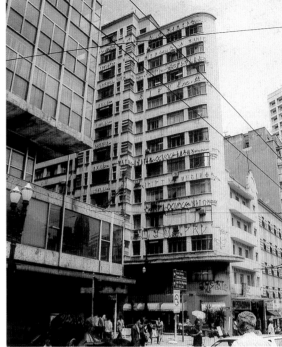

São Paulo, 2004

'Juneca', and every kid that saw it seemed to grab a roller and go for their own fame as well.

*Pichadores* keep their media simple. Though many will use spray-paint, it doesn't work as well visually, and fat caps are not used because they are unavailable. Marker tags are virtually unheard of. Instead, the weapon of choice is the 2- or 3-inch foam roller with an industrial colour of bucket paint. A popular method is to carry your latex paint around in a plastic soda bottle. *Pichação* does not get colourful. It is a no-budget medium, one whose beauty is governed by the aesthetics of sheer will. *Pichadores* usually thin down their latex paint with water to make it last, and if paint is unavailable (it's a risky move to steal paint in São Paulo), it isn't unheard of to use mud or some other concoction. Once in a while, a *pichador* will come upon some road tar, which is a real score – ever tried to scrub tar off a wall?

When tags are done well, they are spaced out as widely as possible without using excess paint or a larger roller. Practically everything in the city to a height of 15 or 20 feet is slaughtered, and it is just as common to lean over the tops of buildings to write on their façades. Totally crushed walls are called an 'agenda', as in the calendar in which you write all your appointments. The spot is everything.

*Pichação* crews will send twenty guys into a building and catch tags outside every single window. If it means you need to break every window to do it, so be it: this isn't about murals.

Some *pichadores* only write their crew name, while some are solo acts. Even the solo acts will usually have a partner – going out to tag alone at night in São Paulo is a scary proposition. Some of the most prolific names are groups of fifty or more, while some are just one extremely dedicated person.

Modern *pichadores* in São Paulo use a print style that has its roots in rock and roll album cover typefaces, with some elements of the Old English fonts that the Latino gangs in Los Angeles have used since the 1930s. The rock and roll styles draw from the cover art of bands like Pink Floyd, Led Zeppelin, Black Sabbath, Motorhead, and so on. However, *pichação* has developed and progressed to the point where these influences are really only trace elements of what is seen on the walls: fierce, intimidating and very well-developed prints.

There are some visual rules – for example, the letters of the tags should be uniformly tall and wide, meeting an invisible and straight guideline at the top and bottom of the name. The letters should usually be separate from one another. In addition, the breaks and bends of the tag's letters should (again, normally) be at a consistent elevation (e.g. two-thirds of the way

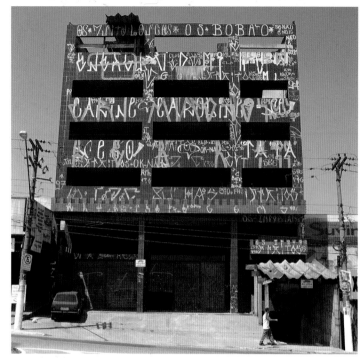

São Paulo, 2004

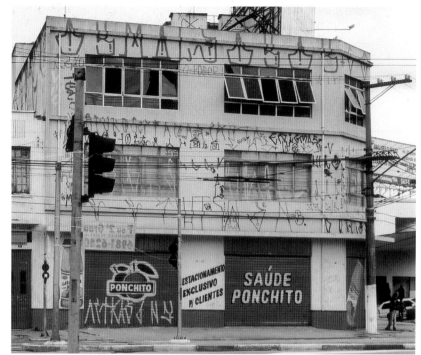

São Paulo, 2004

to the top of the letter). If they are done well, *pichação* tags are as calligraphically strong as any on earth.

While *pichação* took root first and most strongly in São Paulo, it has a presence in every major city in Brazil, and there is a great variation in regional styles. In Rio de Janeiro and Salvador, for instance, only spray-paint is used for *pichação*, rather than rollers. In Rio de Janeiro, these spray-painted tags are small, with tight, looping and often symmetrical forms. In Salvador, in contrast, *pichação* is big, often marking the entire length of a building. To the graffiti aficionado, both of these styles of *pichação* look a bit similar to the tagging style endemic to Philadelphia in the US, but they are of course completely unrelated.

*Pichação* in São Paulo quickly evolved into a serious business. Early writers such as Tchentcho set the tone by writing on the highest façade of the Edificio Italia, which at forty-six storeys high is the tallest

building in São Paulo. To paint this spot, which looms over the city centre and the Praça da Republica, Tchentcho had to lean face-down off the edge of the roof, staring straight down 500 feet to street level with his feet and his life in a friend's hands. The next day, the newspaper story and photos of the damage done fed the fire of fame. Tchentcho was a legend, and the domino effect began. Being the tallest building in town, the Edificio Italia was an obvious target, but the *pichadores* competed for such newsworthy snipes, trashing monuments and statues – including the Museo de Arte de São Paulo, and the entire façade of the Teatro Municipal, São Paulo's postcard civic pride. Still, the ultimate piece of one-upmanship had to be Os Diferentes, who went to Rio de Janeiro and tagged the Cristo Redentor statue – the national symbol of Brazil itself – got caught, and bragged about it in the papers the next day anyway.

The *pichadores* in São Paulo gather at various locations in the city, such as the Largo de Memoria, marked by a tall obelisk, which is, of course, thrashed to hell. *Pichadores* don't carry blackbooks for their heroes to sign, but will ask them instead to do their tag or tags on a single page of white paper, which they keep in a plastic pouch such as one would use for schoolwork. Over twenty years old and as popular as ever, *pichação* culture has evolved and has a few clothing brands and rudimentary fanzines and videos. As large as it is, the São Paulo scene remains very insular and separate from the culture that has sprung up around graffiti in the rest of the world. Most of São Paulo's *pichadores* have never left the city and are surprised to hear that *pichação* doesn't exist elsewhere in the world.

*Pichação* took off for a simple reason: São Paulo is undoubtedly one of the ugliest cities in the world. Since 1970 its population has increased by over fifteen

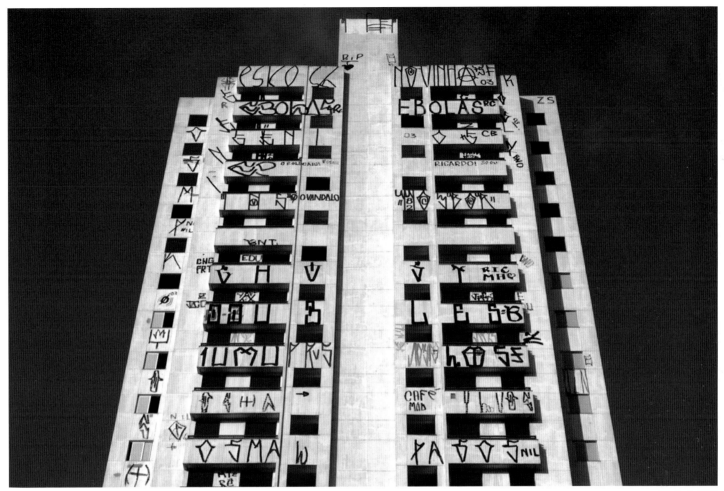

São Paulo, 2004

million people. That alone is nearly twice the population of the five boroughs of New York City. São Paulo's growth continues, and every horizon in the city today ends in countless tall, concrete apartment blocks. The city's historic colonial architecture is pretty much doomed, since the costs of renovating the classic old colonial homes and municipal buildings are high, and the buildings are too small to begin with.

Space is at a premium on São Paulo's city walls. Up is usually the way to go, and crew teamwork is the way to make that happen. Most hip-hop graffiti writers have jumped up on a friend's shoulders once or twice to catch a tag. In *pichação*, competition forces crews to figure out how to make a human ladder four people high. By necessity, it's usually the youngest (and smallest) crew member who ends up on top and doing the tag itself, so the crew elders are sure to teach him how to do it properly. The youngest *pichadores* might be ten or eleven. Most will quit by their late teens, or go all out until their mid-twenties. There are a few that keep at it into their late twenties or even thirties, but *pichação* is a destructive lifestyle. Being caught from time to time is expected, and often it means a beating by either the police or neighbourhood heroes. However, the glory and the fun keep the older *pichadores* going and the new ones coming.

*Pichação* is a vehicle for the youth of the city to assert their existence and self-worth, and to do it loudly. As a social protest, *pichação* is brutal, effective and pulls no punches. There is no country on earth with a worse distribution of wealth than Brazil. For the rich, there are nice buildings. For the poor, there are shanty towns. *Pichação* exists on the very surface of the contested wealth, and promises to keep on punishing the fortunate until they produce a world less punishing to begin with.

São Paulo, 2005

# 10.20 p.m.

I meet R., M. and P. at Avenida São João, a block down from the most famous corner in São Paulo, immortalized by Caetano Veloso in the song 'Sampa'. They start their *rolê* in a nearby alley, climbing on to shoulders and helping one another to the small ledge above the first floor. They start writing – 'OS G.S.', 'AGENTES' and 'LERDOS'. A few people walk by and say nothing. Another says to his companion, 'In the old days I would have shot them both on the spot.' Getting down is tougher than climbing up – a long dangling drop off the ledge.

Shimmying up pipes and bars, they quickly scale the next building. On reaching the second floor, a light goes on, and a concerned apartment owner appears between the bars of his window. R. and P. keep climbing further up. Another resident appears at a fourth-floor window, staring down at the action.

R. tells them to relax, that they aren't there to rob them, just to paint. 'OS G.S.' and 'AGENTES' appear in large letters between the second and third floors of the building. R. and P. climb down and joke with a pair of passing transvestites.

M. is writing out his 'LERDOS' mark above another second-floor window as the other two sit on the curb and watch. A police car drives past and M. lies down on the ledge. At the corner the car reverses hastily to R. and P., the cops get out and order them to put their hands against the wall, along with those of a male passer-by with a backpack. I'm told the same, but their attitude to me changes when I greet them with a polite 'good evening'. A minute later another man arrives. He is the first-floor tenant who had watched the *pichadores* at their previous target, and he is now pleased with himself: he 'had caught the vandals'.

One of the cops is a policewoman, now berating R. and P. that they are ruining the city, that they have no sense of civility, and that they don't know how to live in society. The passer-by with the backpack is offended by these accusations and barks back to the lady cop that he is a juggler who volunteers at hospitals entertaining children with cancer. R. and P. just laugh at the situation, as they have both been busted numerous times for violations of article 163 – vandalism. This upsets the cops, who tell them to stop laughing. The tenant points his accusing finger at my camera and me, saying that I hold the proof of the crime. Having long since changed memory cards, I offer up a small slide of innocent street photos. I ask politely if I may photograph what is happening, but the cops refuse, threatening to take my camera.

M. is still trying to make himself invisible on the high ledge across the street. The tenant spots him, and soon M., R. and P. sit in the back seat of a cop car as I make small talk with the policewoman, convincing her to let the innocent juggler go. The hero tenant will not shut up, complaining about the city's vandalism. The police officers roll their eyes: we are only blocks away from *cracolândia* (crackland), one of the worst spots in the city for open drug use. The police interrupt and brusquely ask the tenant if he will follow them to the precinct and testify against the kids. He refuses, but says that I too am guilty of 'sponsoring' their illegal activities with my photography. The cops laugh at this,

saying that every TV cameraman would be in jail if this were worth prosecuting.

Unwilling to testify or press charges, the tenant stands befuddled and powerless. I follow the cops to the station to find out what will happen to the *pichadores*. They are taken in and their records are checked: P. is a minor and there is nothing that can be done except to call his mother and let him go. The others have numerous prior offences. The officer on duty is willing to talk for a few minutes, but it is a busy night. He is upset about having to deal with this on his watch, since violent crimes and drug trafficking are happening as we speak. He'd like to talk more, but a drug dealer was busted and he has work to do. I ask to speak to the kids, but he cannot allow this. He says he'll release them later. *Pichação* may be the worst of the graffiti crimes in São Paulo, but that doesn't make it a priority. The officer isn't concerned about what he considers utter banality, and he says fighting *pichação* is like *enxugar gelo* — trying to dry ice cubes.

All three *pichadores* are out on the street again in time for breakfast.

IGNACIO ARONOVICH

São Paulo, 2005

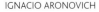

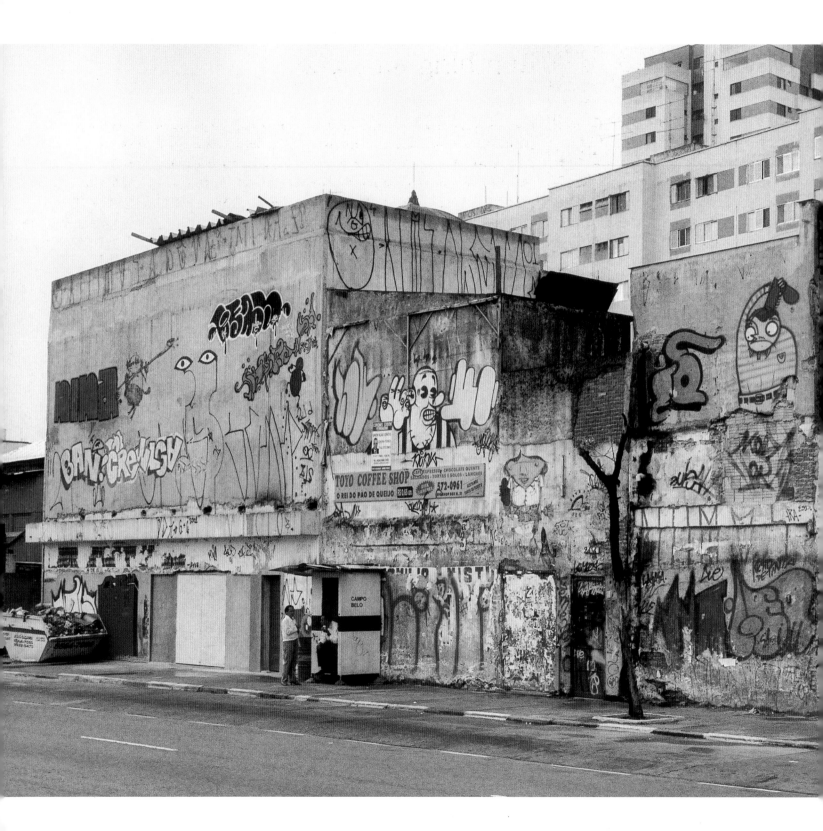

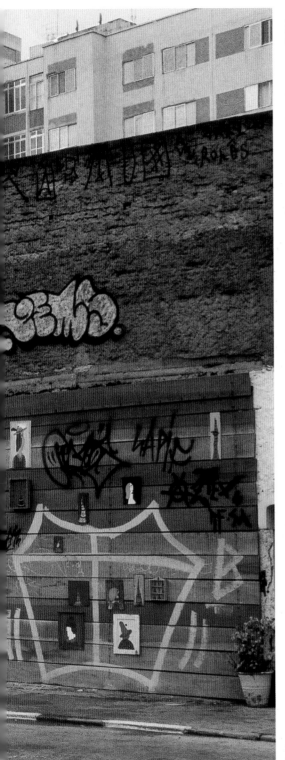

# Bombing (*Rolando nas ruas*)

Cars blurred by us and shook the thin pavement. We stood on a narrow concrete platform a few feet away from seven lanes of raging traffic. A flat concrete wall without windows towered up six storeys from the edge of the platform. Scaling a pair of 26-foot ladders, lashed one above the other with binder's twine and a length of old extension cord, my companions took turns gingerly climbing up to the height of a five-storey building and painting, the ladder groaning and buckling like a sapling far too tall for its width. With my stomach in a knot already, I passed on scaling the ladder, and I began a painting at ground level. As the ladder shook above me, I ran out of latex paint. We had no water, and one of my companions told me to make some myself, pointing me and my near-empty gallon of latex paint into a nook behind a tall shrub. With a trembling man painting on a windswept ladder five storeys above me, I rolled out paint thinned with my own urine as the police arrived. The painter atop the ladder kept at it, while his partner held the ladder steady and stayed on message with the police: 'Of course we have permission, officer. My partner up there on the ladder has the permit slip, and he's busy now. We're not doing *pichação* – this is *art*!'

CALEB NEELON

Street bombing in Brazil occupies a delicious middle ground between the universally loathed *pichação* movement and the generally well-received elaborate graffiti murals. Most of the simpler street paintings in Brazil, whether based on letters, characters or abstract forms, are filled in with latex paint, outlined with spray-paint, and sharpened up again with the ubiquitous tiny paint roller with which all street painters in Brazil are well acquainted. It is not uncommon to see street work executed entirely in latex paint. Entirely spray-painted works also abound, though the high cost of spray-paint is prohibitive for many street painters. The high cost of materials is certainly a contributing factor to the development of several methods of street bombing in Brazil.

Particularly expansive walls in São Paulo often end up covered in a *sopa de letrinhas*, or 'alphabet soup'. A group of graffiti writers will begin one by painting a number of bunched-together throwups at ground level. Other writers will come along – often at the originator's prompting – and paint their own throwups or characters slightly higher, above the first set, and connect them to the growing mass. Often lasting and evolving for years, a *sopa de letrinhas* can stretch over an entire city block, be several storeys tall, and incorporate the work of dozens of graffiti writers, regardless of whether or not they all know one another.

Whether it originates out of respect for the high cost of materials or out of a better and more friendly society, there is a great deal of care taken in Brazil not to paint over the work of others – far greater than in graffiti scenes in the rest of the world. Astute graffiti writers will avoid covering *pichação*, and *pichadores* generally leave graffiti alone, unless the graffiti had been painted over *pichação*. This mutual respect translates into innovation and creative use of space, particularly the endless concrete stretches above ground level. Going up, of course, demands a way to get there. The ladder – whether made of wood, metal or one's friends – has become an essential tool for the motivated street bomber in Brazil, with available space at street level at a premium and higher spots often offering a greater degree of permanence. Besides, it's cooler to be the one on top.

Derelict shop fronts with work by Loucos, Nunca, Coio, Sonik, Os Gemeos, Nina, Zezão and Vitché, São Paulo

# Lettering
*(Sopa de letrinhas)*

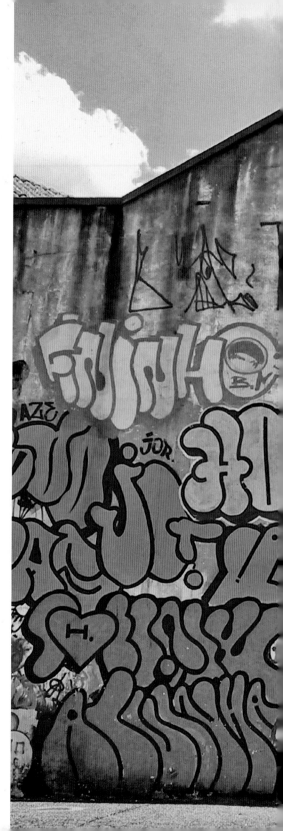

Lettering as a whole is a peculiar art form. When legible, the connection with the viewer is very direct; when illegible, it is a closed system. Whether legible or illegible, there is a great deal of inside information that will be totally opaque to the outsider, as every serif and change in line weight has a story and an origin. Graffiti is, on the one hand, a public and easily accessible celebration of line and colour made public and, on the other, an esoteric folk art full of self-reference, in-jokes and other recondite information closed off to those not in the know. *Pichação* works in a similar fashion, save the colour. Even experienced graffiti writers from outside Brazil find *pichação* illegible and difficult to understand at first.

There is a great deal of graffiti in Brazil that is consciously rooted in the tradition that emerged from the New York City subways, and as such it operates as part of a global movement. However, the material costs of graffiti pieces entirely in spray-paint is generally prohibitive, and next to aerosol paints such as Rust-Oleum, Montana or Belton – all of which are unavailable in Brazil – the quality of the spray-paint in Brazil is mediocre at best. Because of these factors, Brazilian writers who do not improvise and adapt the traditional techniques of graffiti to their situation have a distinct competitive disadvantage against writers from North America, Europe or Australia.

The *grapixo* technique is a purely Brazilian concoction, and is the first hybrid to emerge between São Paulo's *pichação* and graffiti movements. *Grapixo* draws on the concept of multicoloured and time-consuming pieces and murals from hip-hop, blending them with the spindly, angular typographical style and sensibility of São Paulo's roller and latex paint *pichação*. Several of its practitioners are involved in graphic design and bring its razor-clean lines to the streets via latex paint and rollers, a combination that can provide a cleaner line than even the most carefully controlled spray-paint. *Grapixo* is a recent and rapidly developing phenomenon, one especially well-suited to the confluence of media, styles and surfaces of Brazil.

*Sopa de letrinhas*, São Paulo
**Overleaf** Giant *grapixo* letters by Os Gemeos, Coio, Wozy and Ise, and character by Os Gemeos, São Paulo, 2004

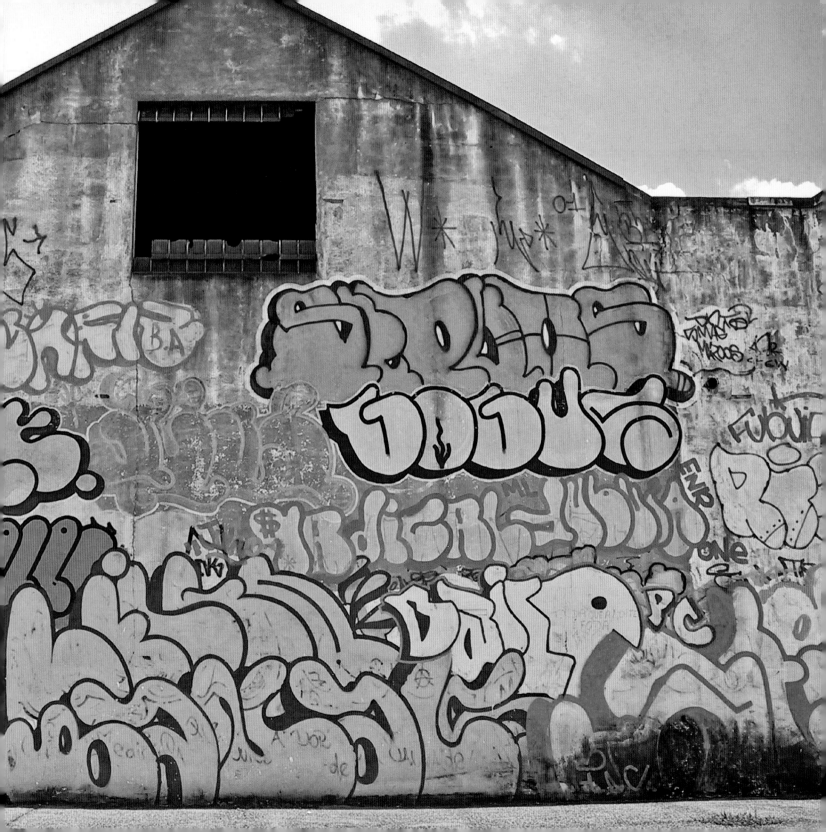

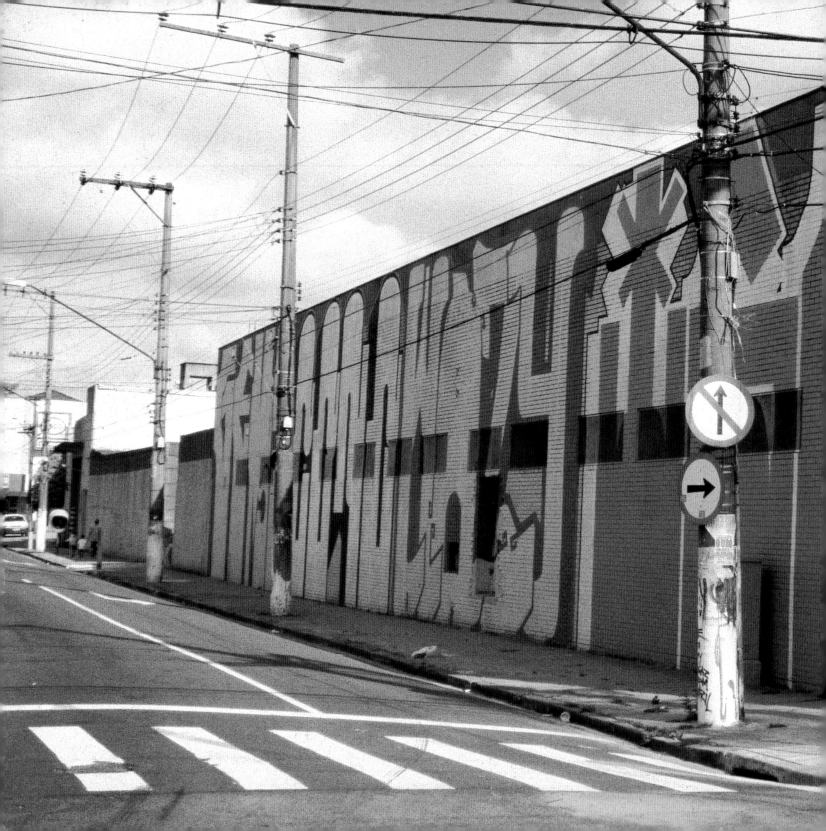

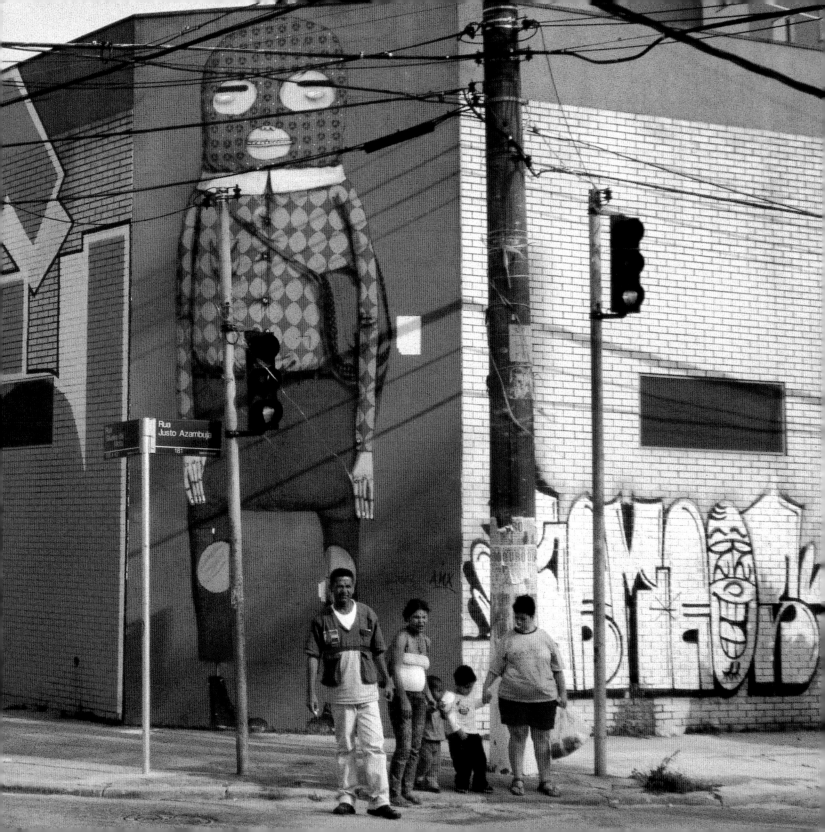

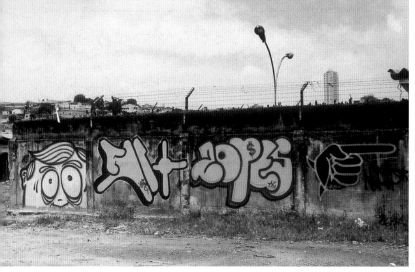
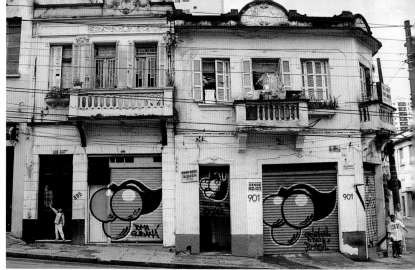
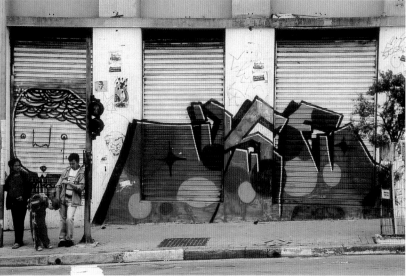
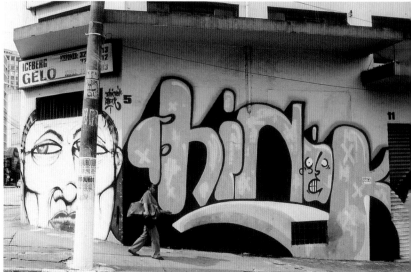
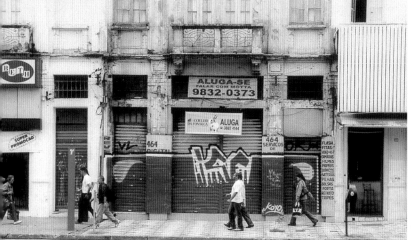
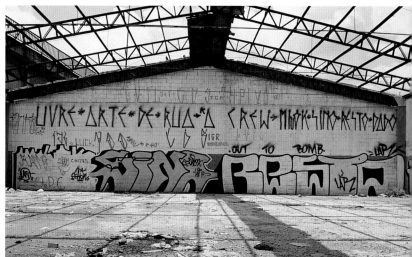

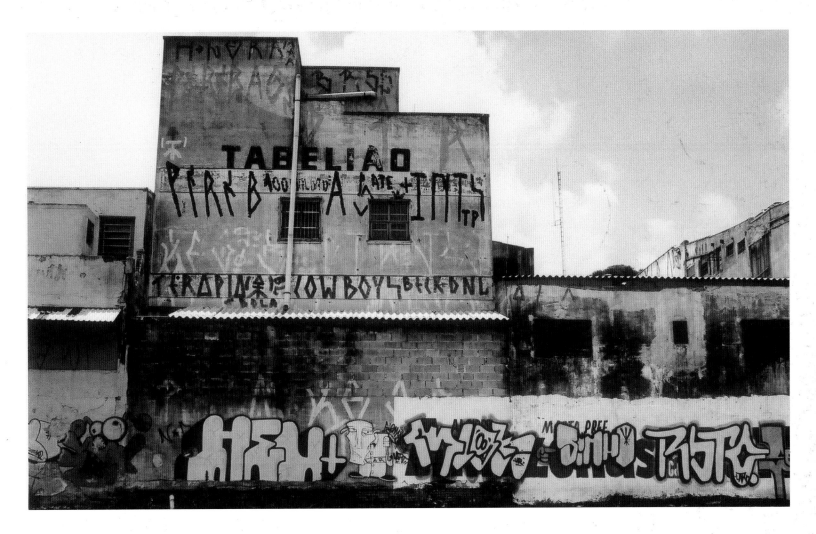

**Opposite**
**Top left** Sino and others, Itaquera, São Paulo
**Top right** Guarana berries by Nunca, São Paulo
**Centre left** Letters by Ise, with character by Spit, São Paulo

**Centre right** Zefix and Phinok
**Bottom left** *São Paulo Terra de Gigantes*, letters by Ise, São Paulo
**Bottom right** Sino and others, Itaquera, São Paulo

**Above** Unknown artists, Itaquera, São Paulo
**Below** Binho, Os Gemeos and Vitché

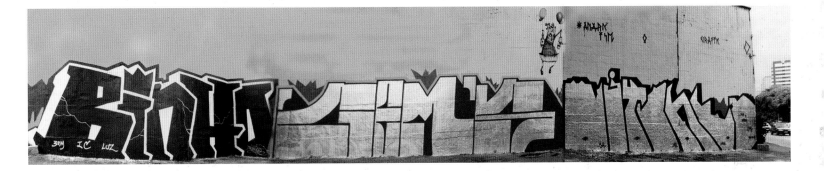

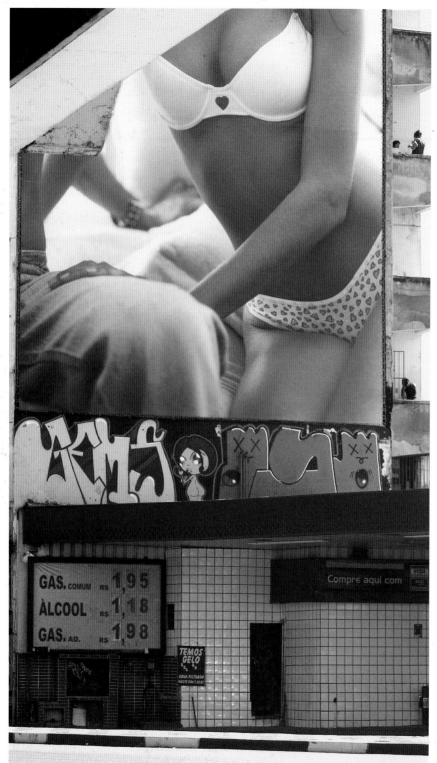

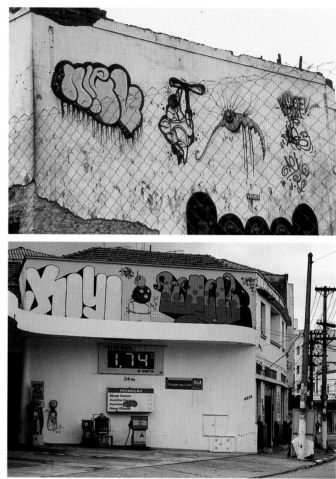

**Left** Os Gemeos and Ise, with a character by Nina, São Paulo
**Above top** Unknown artists, São Paulo
**Above bottom** Coio and Os Gemeos, São Paulo

**Opposite**
**Top left** Zezão (Viciofds), São Paulo **Top centre** Dion,
São Paulo **Top right** Unknown artist, São Paulo **Second row,
left** Ise and Os Gemeos, São Paulo **Second row, centre**
Unknown artist, São Paulo **Second row, right** Ise and Dion,
São Paulo **Third row, left** Koyo, Nunca, Loucos and others,
São Paulo **Third row, centre** Erro, Coio, Loucos and others,
São Paulo **Third row, right** Onesto, São Paulo **Bottom
left** Coio, São Paulo **Bottom centre** Ise, São Paulo **Bottom
right** Ise, São Paulo

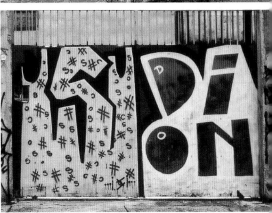
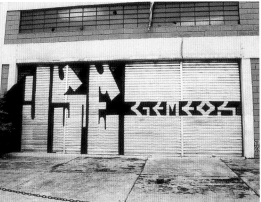
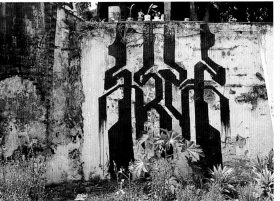
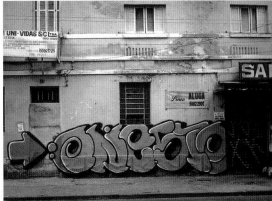
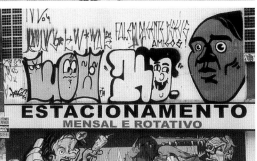

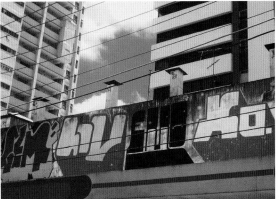
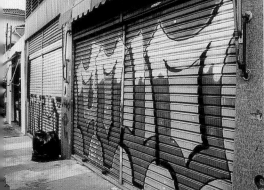
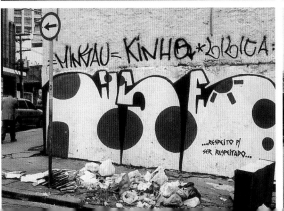
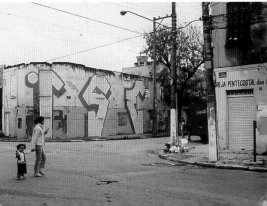

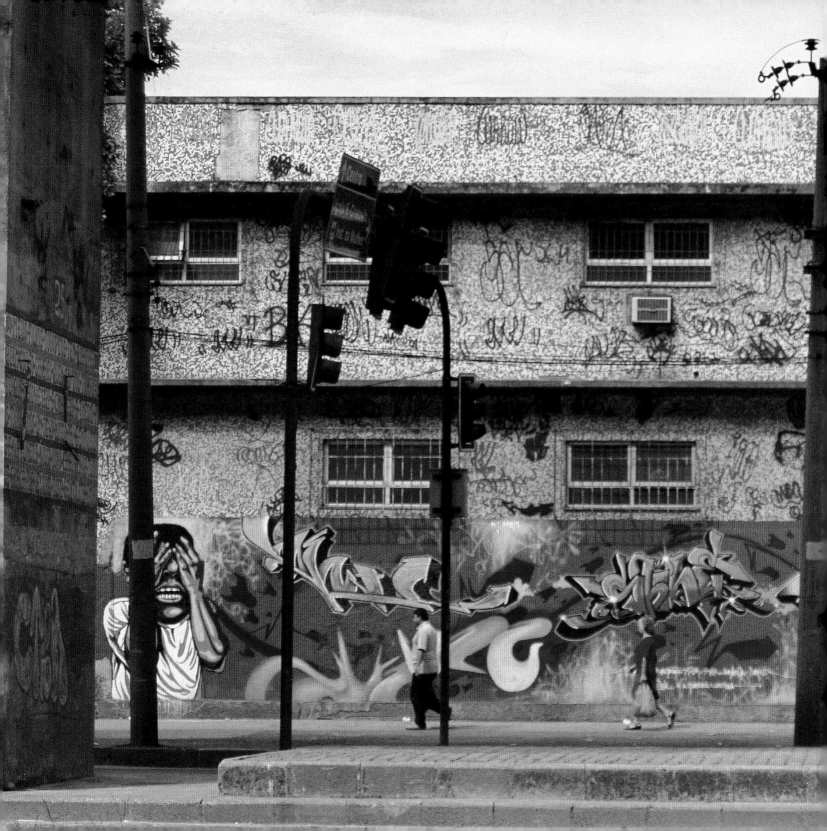

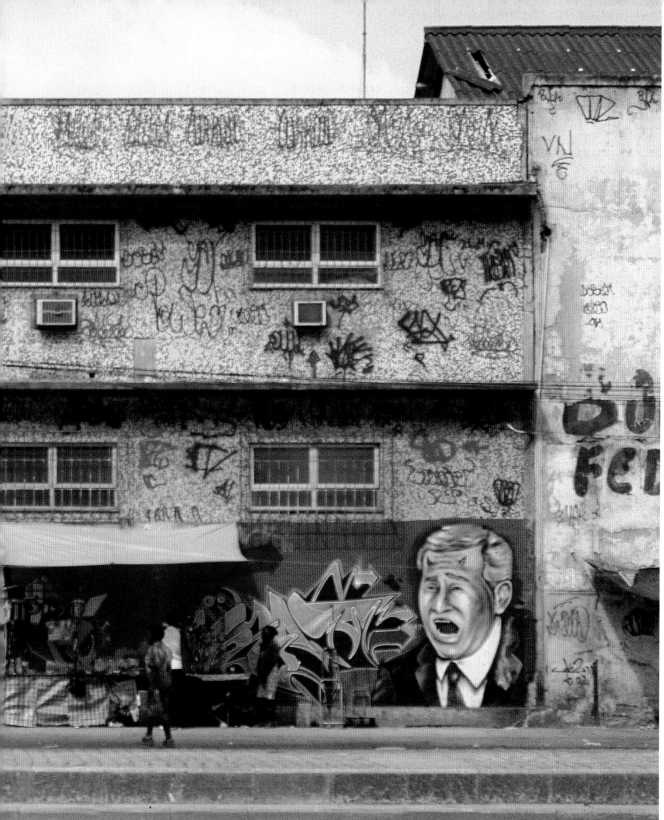

Nação Crew, Crespo, Stile,
SWK, Bragga and Ment,
Rio de Janeiro, 2004

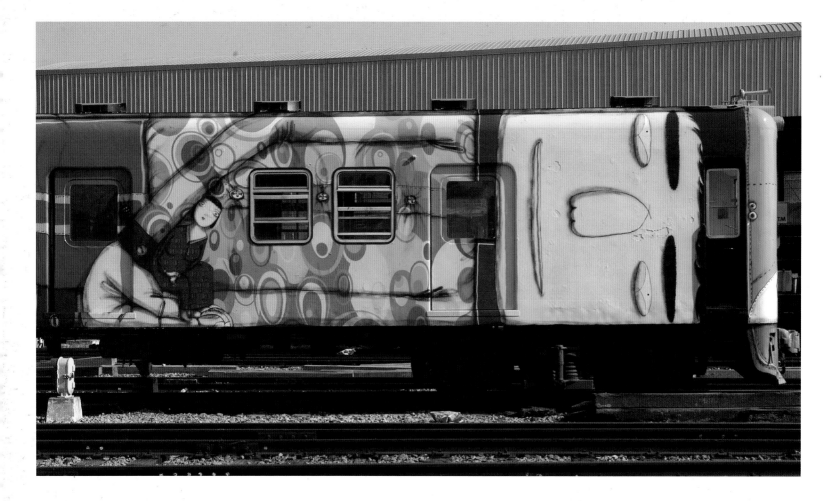

# Trains

Graffiti on trains was a piece of the hip-hop puzzle that never quite caught on in Brazil. While cities such as Amsterdam, Rome and Warsaw became renowned graffiti Meccas at different points in the 1990s for their vibrant train-painting scenes, this has never been the case in Brazil. Buses, not trains, are generally the way to travel, and the subway systems that exist in Brazilian cities such as São Paulo, Rio de Janeiro and Belo Horizonte are symbols of civic pride and are extraordinarily well guarded by armed men who are not shy about using their guns. Since writers in these cities can paint prominent – and longer-lasting – street spots with far less risk, trains have never occupied the same place in the spectrum of graffiti in Brazil as they have in other cities in the world. Nevertheless, the trains beckon certain writers who are not content to see them so clean, even if that means painting them legally, as Os Gemeos, Nina and Ise have done in recent years.

**Above** Os Gemeos, São Paulo, 2004
**Opposite top** Nina, São Paulo, 2004
**Opposite bottom** Carriage of faces by Os Gemeos,
with homage to José Borges by Ise

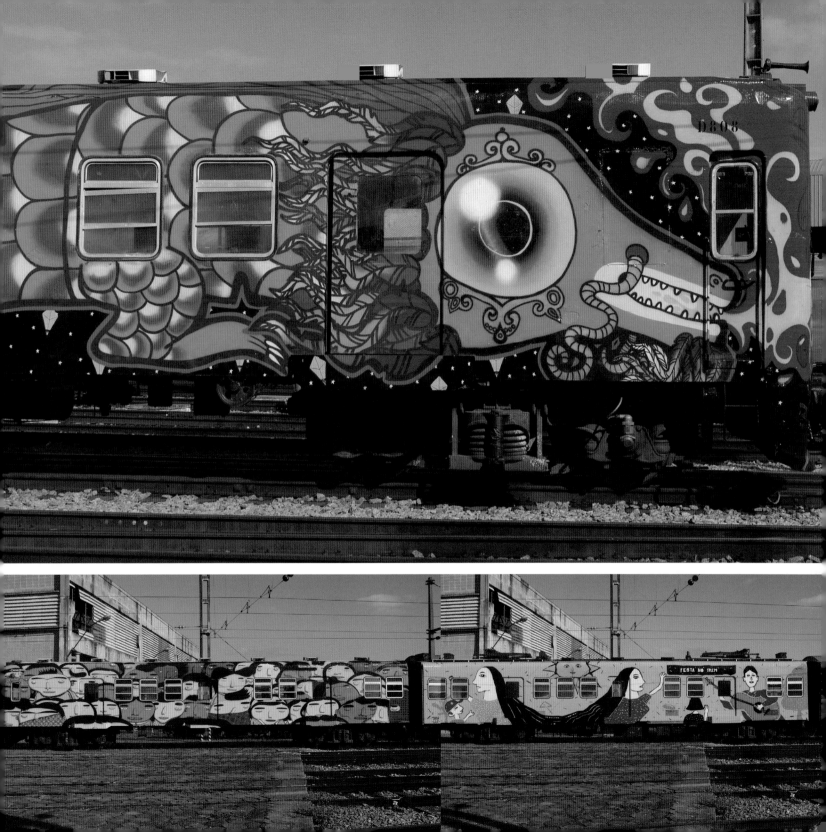

# Productions: Legal and Illegal

Out of necessity, graffiti writers in many parts of the world create their most elaborate and time-consuming works in corners of the city so hidden and obscure that regular inhabitants never see them. Brazilian street painters generally don't see the point of this and tend to focus on creating large street works that will be seen by many people. Part of this is simply that there tend to be more available spaces to paint in Brazil: there are substantial numbers of highly visible abandoned buildings and municipal walls whose monochromatic tones are not held to be sacred by the population and law enforcement. Brazilian writers also tend not to get as hung up on the distinction between legal and illegal work as their North American and European counterparts. While writers elsewhere knock each other for 'only doing legals', it isn't something you often hear in Brazil.

As spray-paint productions are so expensive in Brazil, it is little surprise that graffiti writers there have often sought official sanction (and sponsorship) for their most elaborate works. The constant presence of *pichação* on every public wall, particularly those that are the most prominent, certainly helps the permission process. Walls in São Paulo in particular never stay clean for more than a few weeks, and property managers often see their way to an arrangement for a mural in the hope that it will keep the wall in their charge free of *pichação*.

A number of writers, most notably Os Gemeos, have sought and received commissions for public artworks in Brazil on a public scale of the highest magnitude. Some of these projects have included legally painted passenger-train wholecars, gigantic murals on Avenida Paulista and, with their colleagues Speto, Vitché, Tinho and Herbert Baglione, an enormous and heart-wrenching project adjacent to São Paulo's notorious Carandiru Prison.

Detail from a wall adjacent to the Carandiru Prison by Vitché, Tinho, Speto, Os Gemeos and Herbert Baglione, São Paulo, 2001

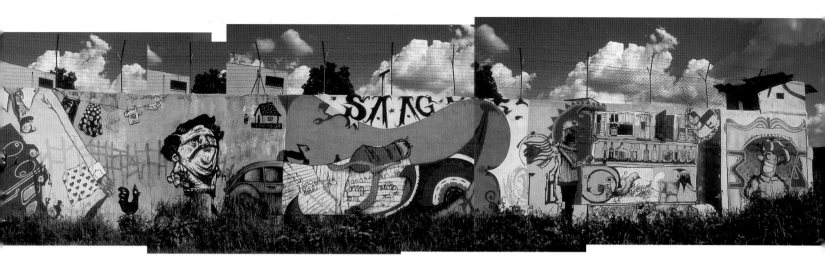

**Above** Mural on a wall adjacent to the Carandiru Prison by Vitché, Tinho, Speto, Os Gemeos and Herbert Baglione, São Paulo, 2001
**Below** Details from a wall adjacent to the Carandiru Prison by Vitché, Tinho, Speto, Os Gemeos and others, São Paulo, 2001

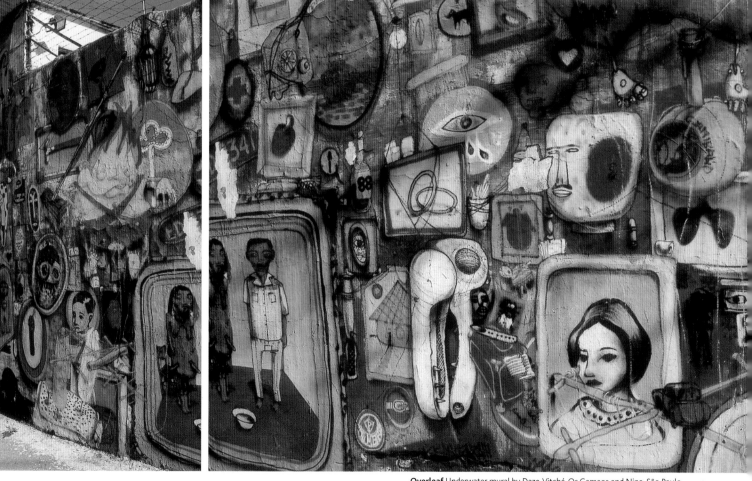

**Overleaf** Underwater mural by Daze, Vitché, Os Gemeos and Nina, São Paulo

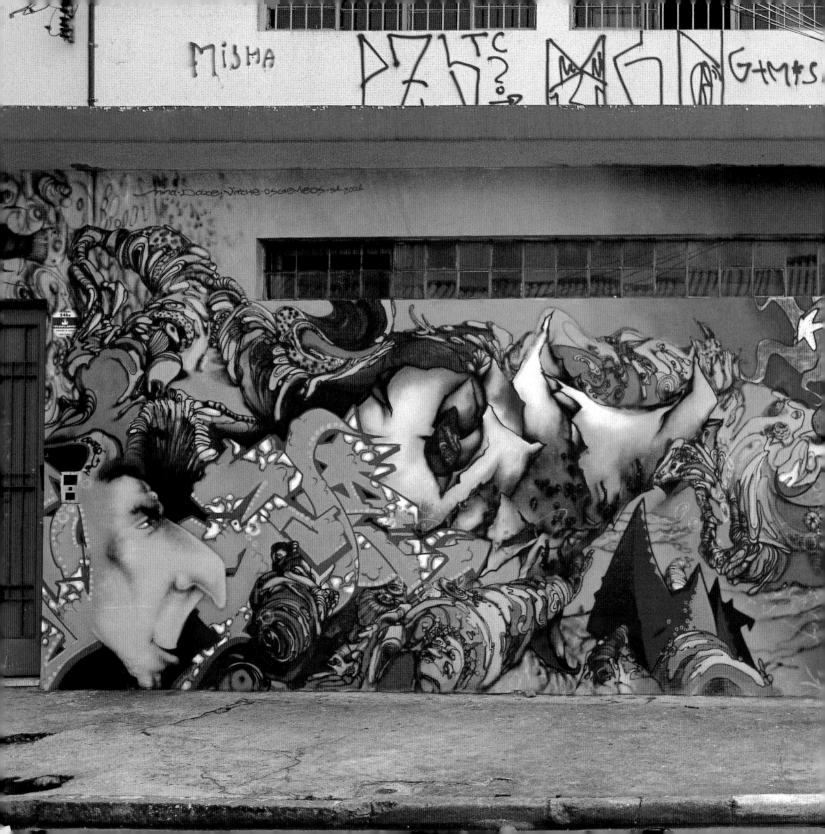

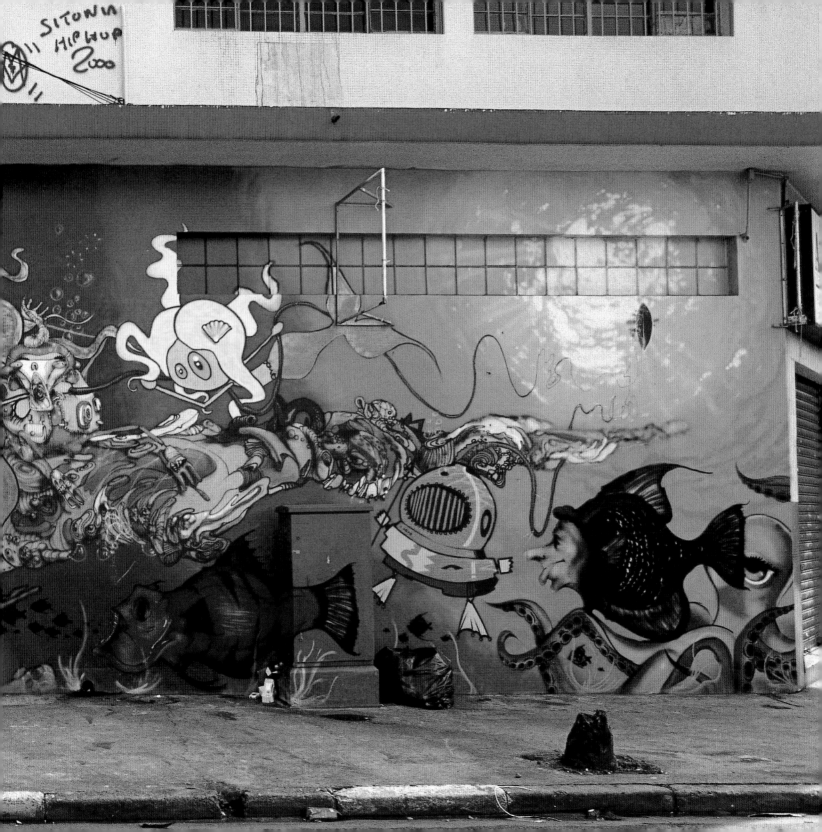

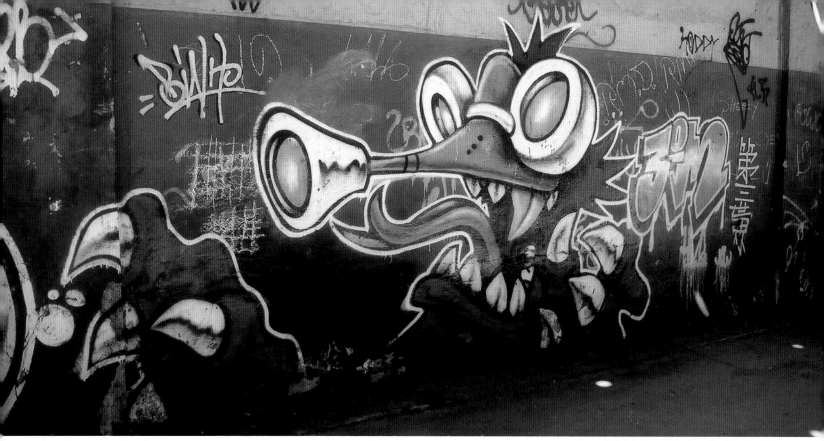

Binho's cockroach character, Rio de Janeiro, 2004

# Binho

Binho is one of São Paulo's original old-school writers and today plays a central role in advancing the Brazilian graffiti scene. He often paints under the name 3° Mundo (meaning 'Third World'), usually incorporating his trademark character – a cockroach wearing a gas-mask – into his pieces. The ever-present cockroach on the Brazilian streets is used to represent the persistent graffiti artist, who always wins out.

After years of painting graffiti in Brazil, Chile and Japan, with writers from all over the world, he now edits and designs *Documento Graffiti*, Brazil's most prominent graffiti magazine. The magazine has become an invaluable showcase for many young artists. His work for the magazine and his connections worldwide have enabled him to organize countless projects across the country. His notoriety has led to a variety of commercial commissions, but it is his love for graffiti that keeps him painting on the street every week.

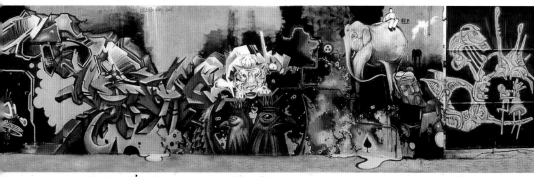

Mural by Binho, Nosm, How, Ciro and Zezão, São Paulo

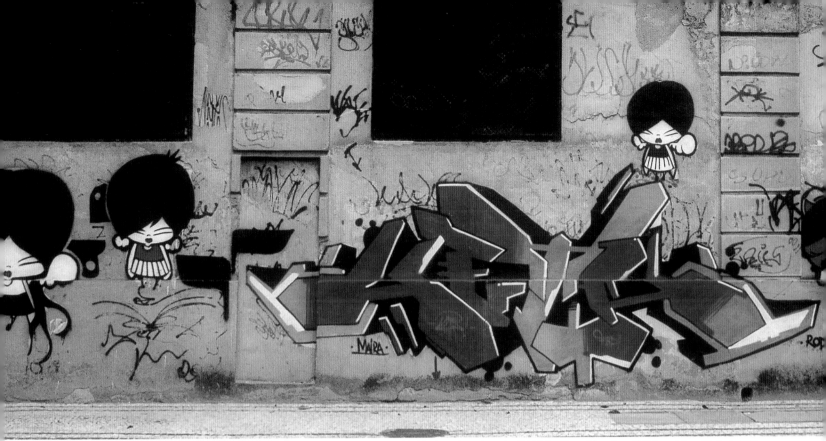

# Fleshbeck Crew

In Rio de Janeiro's south zone you're never too far from a character, throwup or production painted by the Fleshbeck Crew. From the beaches of Ipanema to the concrete flyovers of the central zone, their distinctive vibrant colours and fresh styles are hard to miss. The Fleshbeck Crew is made up of five artists: True, Toz, Lets, Riot and Pia. The name comes from a deliberate misspelling of 'flashback', an in-joke on the way Brazilians sometimes mispronounce English words. Their interests and influences include graphic design and motions graphics, 1980s Brazilian comics, as well as graffiti artists such as Tats Cru from New York and 123 Klan from France.

As a team they excel in both letters and characters. They mix classic New York graffiti and more up-to-date 3D and free-form styles. Their characters are also eye-catching, particularly the floating angels, which have become their most recognizable image. In recent years they have painted with countless artists both nationally and internationally, including Daze who often collaborates with them when he is in the city.

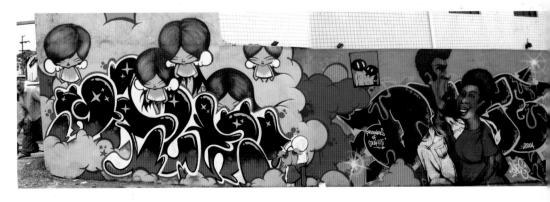

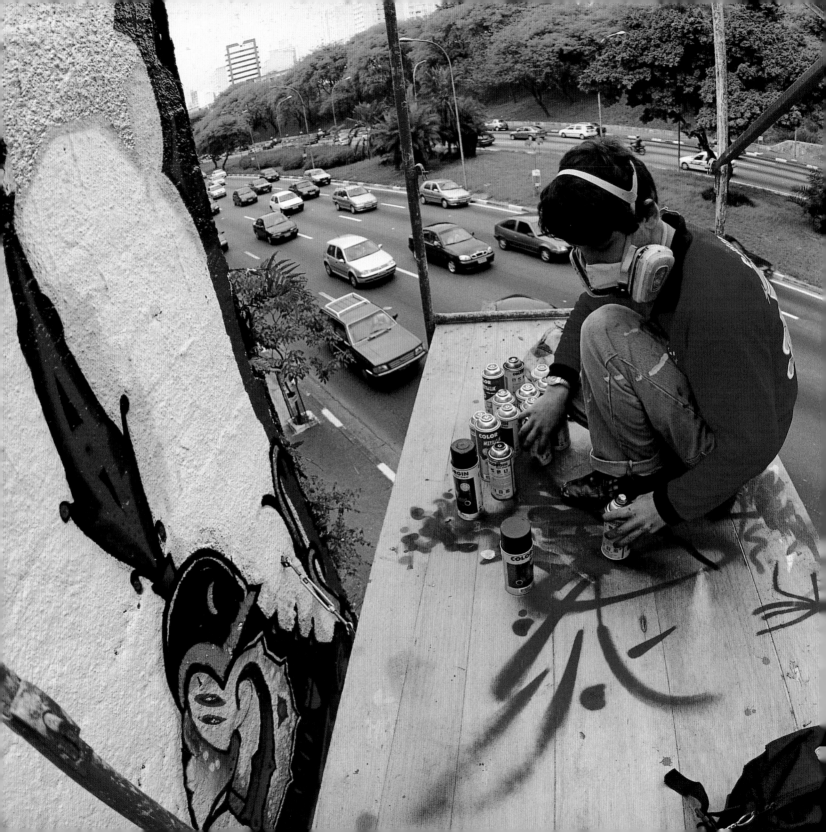

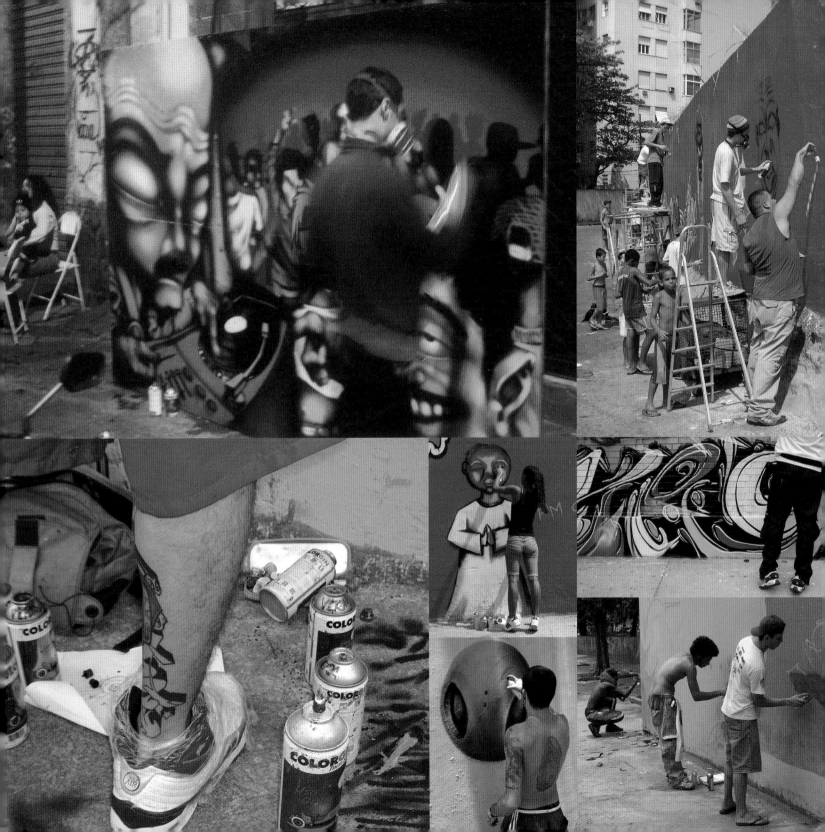

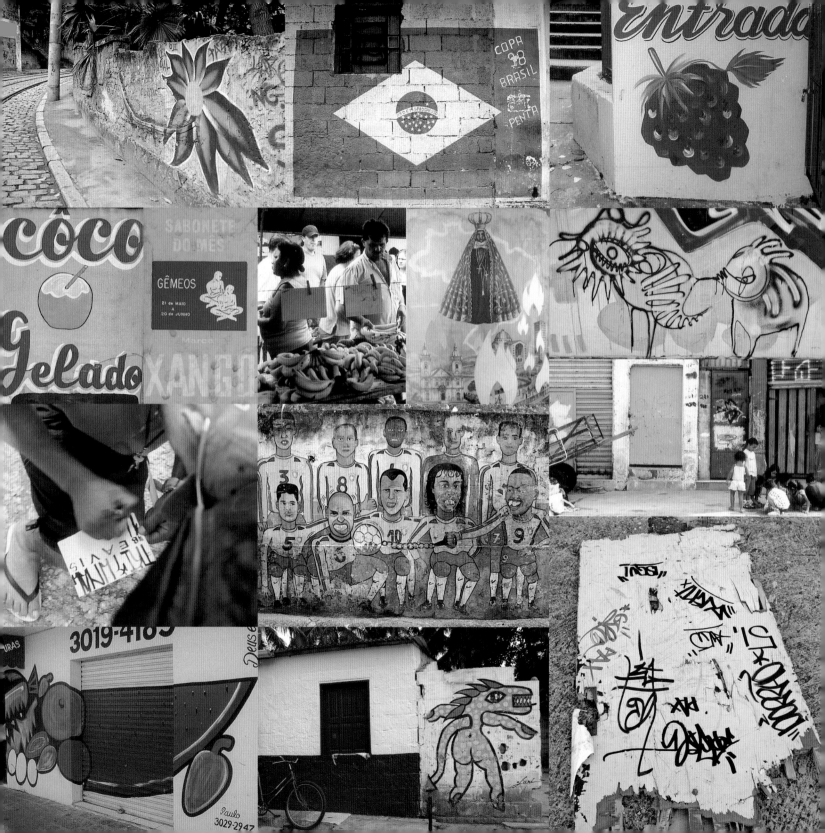

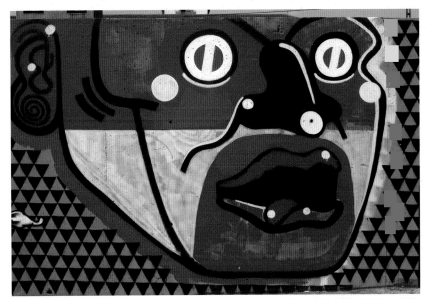

Nunca, Brás Station, São Paulo, 2003

# Brazilian Style

*(Poesia urbana)*

While there is no generic Brazilian graffiti style, there are some themes and influences that are distinctive. The same global issues and obsessions apply to Brazilian artists as elsewhere, but certain cultural factors give an edge to their work.

Brazil may be the result of cultural fusion, but combining different influences in its art is a relatively recent idea. At first, European traditions predominated Brazil's fine art, architecture and literature, while African and indigenous South American cultures had a greater influence on folk arts and crafts. It was not until the 20th century that artists, writers and designers became more critical of imported culture and looked to their own mixed heritage to create art that was uniquely Brazilian. Like their North American counterparts, they wanted to dispel the notion that art from the New World was somehow inferior.

Brazilian artists assimilated modernist movements, such as Surrealism and abstract art from Europe and North America, but they did so on their own terms. They accepted what related to them and satirized the rest. For instance, in 1928 the poet Oswald de Andrade wrote the *Manifesto Antropófago* (Cannibal Manifesto) for a new artistic movement, which proposed the cannibalizing of European culture.

The Anthropophagic Movement was inspired by the true story of Bishop Sardinha, who was eaten by Brazilian cannibals in the 16th century. Since cannibalism was something that existed in Brazil before the arrival of Europeans, it provided a metaphor with an authentic Brazilian bloodline. The manifesto proposed that Brazilians should not imitate but instead devour new ideas, experiment and reinvent on their own terms. Having embraced the most unthinkable human act – eating people – artists were free to say and do things shamelessly.

Cannibalistic art was at first shocking to audiences, but over time this absurdist idea became a foundation for Brazilian Modernism. The Tropicalia music movement of the late 1960s also adopted the idea of cultural cannibalism. Musicians such as Caetano Veloso and Gilberto Gil were 'eating' the music of the Beatles and Jimi Hendrix, seasoning it with Brazilian folk styles and thereby preserving their own identity. Cannibalism has made a recent comeback in the work of São Paulo graffiti artist Nunca, who has been painting stylized indigenous Amazonians on walls interwoven with the word 'cannibal' in *pichação*-style lettering.

This cannibalistic attitude has given graffiti artists the freedom to create new meanings to imported cultural ideas. First, Brazilians modified hip-hop music and graffiti culture for themselves, through changing the language, techniques and visual or musical references. Graffiti artists then took global themes as subjects for their art and reinterpreted them with similar irreverence. For example, graffiti writers Os Gemeos took the theme of terrorism and made

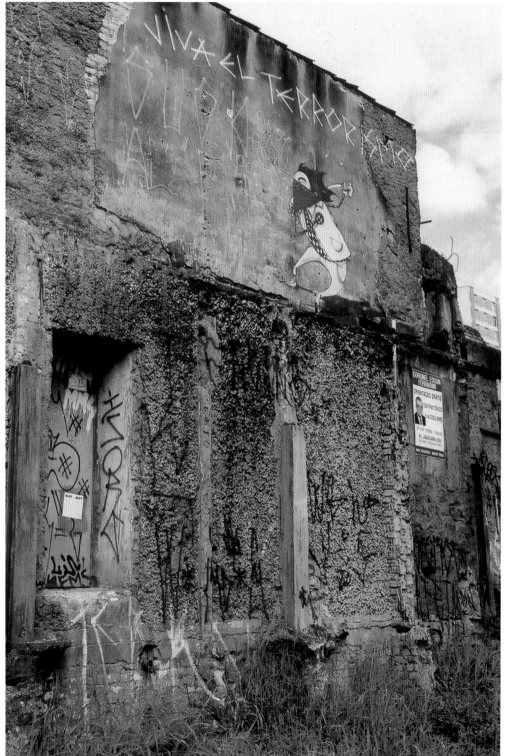

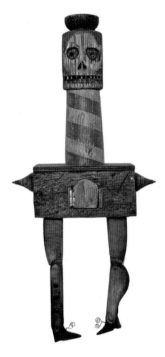

**Left** *Viva el Terrorismo*, Os Gemeos, São Paulo
**Above** Votive sculpture by Vitché, São Paulo, 2004

it absurd. In cities across the world, the twins paint their own terrorist threats in the form of revolutionary characters complete with rocks, Molotov cocktails and slogans such as *Viva el Terrorismo* (Long Live Terrorism). They have even painted a saluting Osama Bin Laden riding a toy aeroplane with the words 'I don't care'. By populating street corners with quirkily dressed anarchists and outrageous statements, such as 'commit suicide for your country', their work makes fun of the war on terrorism. What would be a sensitive subject elsewhere gets 'eaten' and regurgitated into the ridiculous by the twins.

Tribal art by the Tupi people, one of Brazil's original peoples, became the inspiration for painters, sculptors and other craftsmen. Their decorative patterns, ceramics, jewelry and body art have influenced graffiti artists such as Kboco and Nunca. Amazonian designs have also been explored in tattoo art, an

*Cordel* book covers

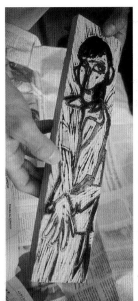

Woodcut by Cimples, 2004

Woodcut print on newsprint, street art poster, Olinda, 2004

artistic expression that is itself another passion or even vocation for Brazilian graffiti writers.

Equally important to Brazil's artistic heritage are the customs of the West African slaves brought over by the Portuguese settlers. Over three hundred years of enslavement, African beliefs survived in an almost pure form in the *orixás* and *candomblé* practices found in many parts of Brazil. The religious rites of *candomblé* were often performed in secret. Followers worshipped a pantheon of deities known as *orixás* in an annual cycle of ceremonies, which included songs and dancing to sacred drums. Slaves were expected to be Catholics. Apart from clandestine meetings, they were unable to worship African gods freely. Instead, they gave their *orixás* Roman Catholic saint-names, covertly practising their religious beliefs.

Even today, millions appear to practise Catholicism but still worship the *orixás*. Catholic and other religious imagery has a strong resonance in Brazil and is often used in graffiti.

Another African custom echoed in the Catholic faith is the use of votive offerings. Brazil has a strong tradition of making 'ex-votos', sculptures of human heads and other body parts, which are used as church offerings for healing. Acting as Catholic relics, they also have their roots in pre-hispanic America and Africa. Ex-votos reflect traditional African woodcarving and have recently inspired artists such as Os Gemeos and Vitché, noticeably in their sculptural pieces, and Barry McGee.

The African tradition of music and dance has played a key role in the development of carnival, one of Brazil's most famous traditional celebrations. Samba, the soundtrack to carnival, has its roots in African village life and the tradition of parading in masks and costume. Brazilian music, from samba to funk, is highly expressive and informs other areas such as painting.

Graffiti artists are now looking more closely at Brazilian themes rather than imported hip-hop images, and so depictions of carnival, folk costumes and masks are not uncommon in graffiti art.

*Cordel* literature is another strand of Brazilian popular art that street artists have been reviving. Originating from the northeast and printed on cheap paper, *cordel* are small books sold in street markets. The name comes from the cord on which vendors used to hang the booklets. From the l9th century, folk poets roamed the region, reciting verses about popular legends and local events and selling the transcribed poems to an attentive peasant audience. Gradually this developed into printed books, which were illustrated with woodblock prints, and, in some cases, the writer and artist would be one and the same. The most celebrated example of a *cordel* artist and writer is José Borges from Pernambuco. Since the mid-1960s

Lambe-lambe poster, São Paulo

Lambe-lambe collages by Fefe, São Paulo, 2004

he has written over 200 titles and produces countless woodcuts today.

Borges's work and other folk art have been a stylistic inspiration for graffiti artists and illustrators today, particularly in the paintings, and more recently in the prints, of Speto from São Paulo. Onesto from São Paulo and Cimples from Curitiba were among the first graffiti artists to use woodcuts and linocuts to make street poster campaigns. Since then, a wave of street artists from Porto Alegre to Rio have been using traditional printing techniques in their work. As a cheap alternative to photocopies, printmaking has a handcrafted appeal that is sometimes lost in mass-produced stickers and posters. Aesthetically but also through lack of funds, Brazilian street artists have been printing on any paper available by recycling old newspapers, election stickers and food labels.

Related to *cordel* are the traditional woodblock posters known as *lambe-lambe* (lick-lick). A technique that has been replaced elsewhere by lithography, they can be seen in most Brazilian cities advertising concerts. Street artists sometimes recycle *lambe-lambe* posters as a surface for new work or as material for collage, such as the work of São Paulo's Fefe.

Brazilian streets provide rich source materials in the textures, hand-painted typography and murals found in any typical neighbourhood. The faded colour on derelict walls and crumbling façades of old colonial buildings provide attractively dilapidated spaces for graffiti art. In contrast, the endless grey concrete found on the fast-expanding highways of Rio de Janeiro and São Paulo provide painting space with a different atmosphere. Compared to those in colder climates, Brazilian city streets are full of life. Street vendors,

garbage recyclers, markets and street festivals – the people who act out their lives on the streets – are yet another source for Brazil's graffiti artists. The 'gaucho', a local street character in São Paulo, is the proud subject of a portrait depicted on his usual street corner, painted by Onesto.

Local people and the homeless are sometimes among the most inspiring graffiti artists, such as a Rio de Janeiro artist who went by the name Profeta Gentileza, or 'Kind Prophet'. Born José Datrino in Cafelândia (São Paulo state) on 11 April 1917, he has become the most renowned religious street painter. During the 1980s he embarked on a public art project in the centre of Rio de Janeiro, painting sermon-like panels of text in sequence, high up on the fifty-five pillars of the Caju viaduct. His work, with its distinctive font, misspelt repetitions of the letter 'R' and featured a

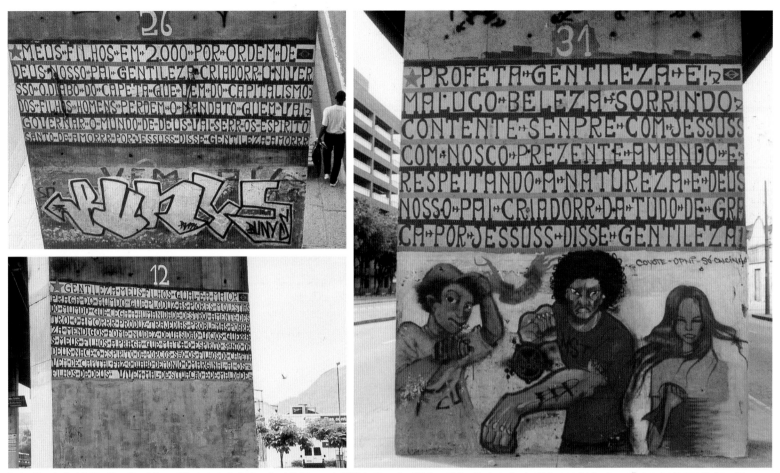

Declarations by Profeta Gentileza. Translations of the text, clockwise from top left: 'My sons in 2000, by the order of God, our Father, Kindness, Creator, Universe – Devil – demon that comes from capitalism of the sons – men – lose their mandate – who will govern God's world? – will be the Holy Spirit? – love for Jesus – said Gentileza – love'; 'Profeta Gentileza – hey crazy guy – smiling – happy – always with Jesus – with us – present – loving – and – respecting – nature – and God – our Father – Creator – of everything – gives everything – for Jesus – said Gentileza'; 'Gentileza – my sons – what is the the biggest plague in the world? – which produces the biggest problems in the world – which blinds humanity – destroys the mind – destroys love – brings tragedies – problems – poverty – beggars – hunger – nudity – addiction – wars – my sons, the plague that kills the Holy Spirit – pig spirit is born – are the sons of the Devil – come from the capital – make the Devil – demon – criminal – the sons of God live in bad situations – and meanness'

striking, recognizable pattern of white, yellow and blue. When Profeta Gentileza died in 1996, a campaign was mounted to preserve his paintings. As a result, his works are considered local landmarks and are maintained and retouched.

For years, Brazilians have felt a need for foreign approval to validate their thriving graffiti scene, but, with more international recognition, they have become more self-confident. Although there is no one graffiti style in Brazil, it is clear that its artists are proud to be Brazilian and weave this passion into their art. This is voiced by Os Gemeos in an interview for *Graphotism*: 'We are proud to be Brazilians and proud to be from São Paulo...to write incorrectly in Portuguese...to live some moments that seem eternal. To use firecrackers in the street. To tell lies to the police. To know that our family loves us. To paint in the street with our clothes dirty from paint. To float paper boats in the rain.' Expressing this self-identity, artists have taken elements of worldwide graffiti culture and added their own twist. Brazilian culture is by no means the only inspiration for local artists, but as São Paulo-based graffiti artist Highraff states, it is their 'roots, culture and collectivity' that make their painting unique.

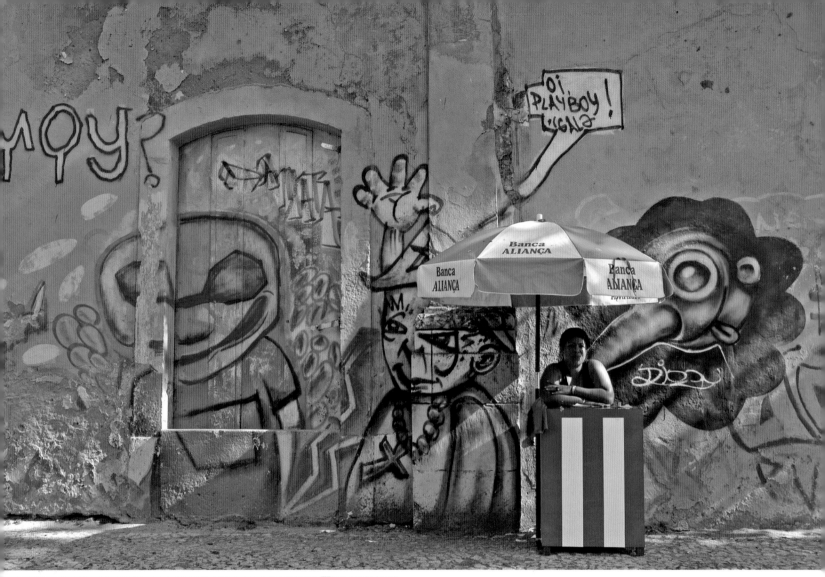

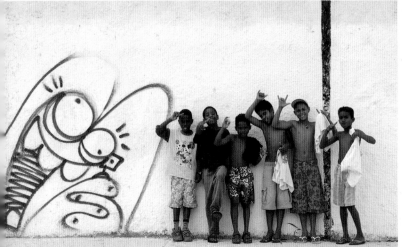

Above Unknown artists, Recife, 2004
Left Binho, São Paulo

Opposite
Top Speto, detail from a wall adjacent to
the Carandiru Prison, São Paulo
Bottom left Highraff, São Paulo, 2004
Bottom right Unknown artist, Salvador, 2004

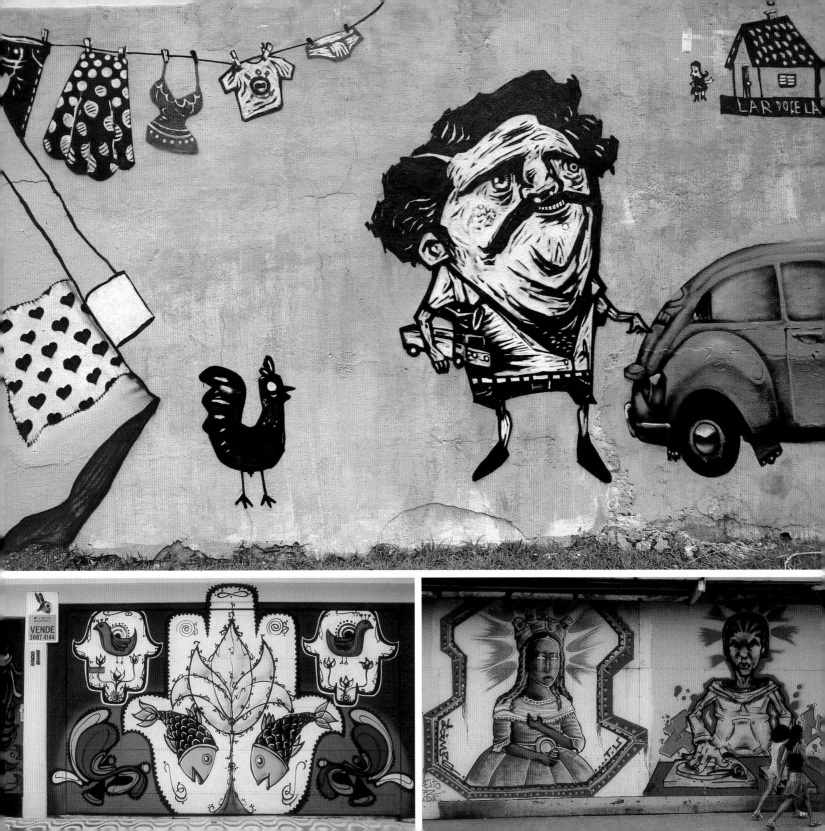

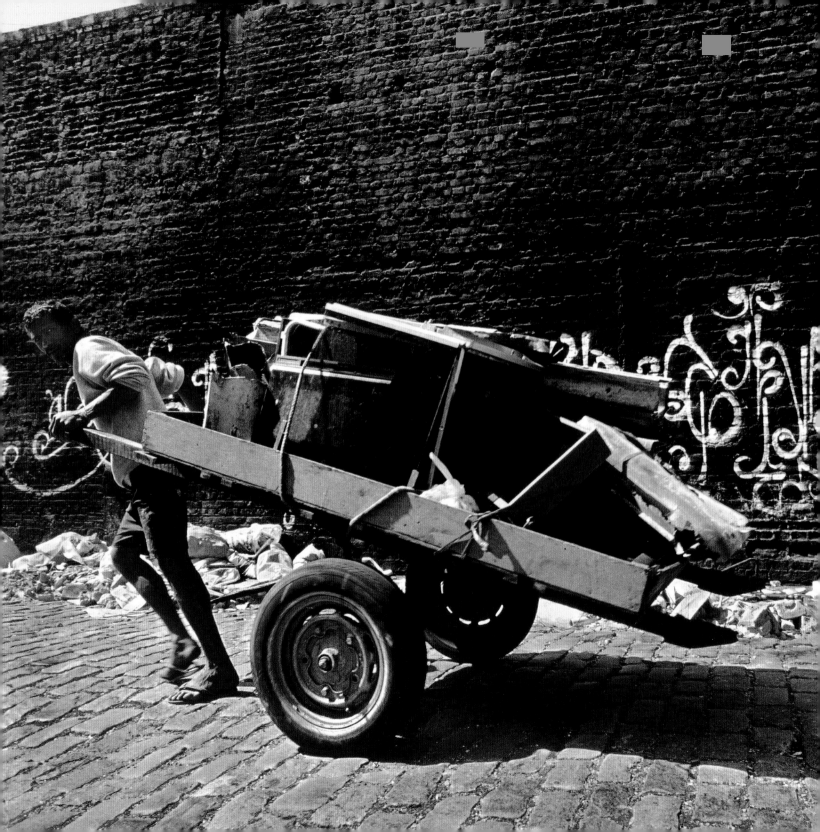

# Characters (*A gente*)

Figurative art plays a starring role in Brazilian graffiti. Its notoriety for character art lies not only in the well-known names but also in the countless other artists who are painting figures across the country. Figurative imagery became popular in São Paulo due to the pioneering work of John Howard and Rui Amaral in the late 1970s. With the arrival of hip-hop, it continued through the influence of graffiti productions that included character elements. After an initial boom of New York-style graffiti, archetypal hip-hop characters were gradually replaced by more original designs. Today, hip-hop-style figures with Kangol hats and adidas trainers still feature, but many artists now take inspiration beyond classic graffiti.

In 1993 a visit to Brazil by San Francisco-based artist Barry McGee introduced a novel way to approach characters. Like John Howard, he painted his figures with nothing surrounding them, but with great detail and depth. His work encouraged others to use their characters outside traditional graffiti productions and paint them directly on the street, where they became more integrated with the found textures and colours of the city.

Placement was key to McGee and other artists painting characters. Such work could be placed interestingly in a variety of well-chosen spots. Characters were more accessible to the public than lettering alone and could be made to relate directly to the location of the painting. For example, Tinho from São Paulo often paints portraits of the local street kids who hang out and watch him paint. Os Gemeos once painted a character saying 'I don't have a RG' (ID number) outside the courthouse where RGs were issued and replaced.

Artists let loose their own vision on an unsuspecting public using characters. Depending on the artist or mood of the piece, approaches to painting switch from sombre to humorous, or finely detailed to quickly improvised. Whatever the style or artist's inspiration, the passer-by gets drawn into their world.

Each artist has his or her own motivations for doing graffiti, either working alone or with friends. Artists' styles can complement each other – for example, Vitché and Herbert Baglione often painted together using a common palette of red, white and black. Working cooperatively is part of the pleasure, taking ideas in new directions. Onesto, a renowned character artist, recollects this camaraderie: 'In the period that the Gemeos and I studied together, one day we [Os Gemeos, Titifreak, Vitché and others] had an idea of painting a war in the desert, using all the characters that represented us, fighting against aliens. The project lasted many years…the painting was great fun.'

For many artists, graffiti is one art form that leads to other avenues. Herbert Baglione, an exceptionally talented artist from São Paulo, is now in demand for his illustrative work by clients such as *Vogue* magazine. Speto, another graffiti pioneer from São Paulo, is a successful illustrator and animator. Both artists still work on the street, even if they no longer regard themselves solely as graffiti artists. Artists such as Speto and Herbert Baglione, who keep pushing their work to new levels, have shown what can be achieved through innovation and a love of street painting, which is an inspiration for numerous younger artists today. The following pages feature some of Brazil's most original figurative graffiti, from established names and examples from past years to the graffiti stars of tomorrow.

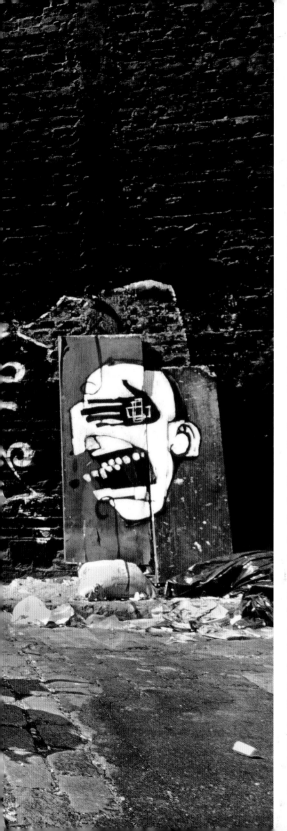

Herbert Baglione, São Paulo

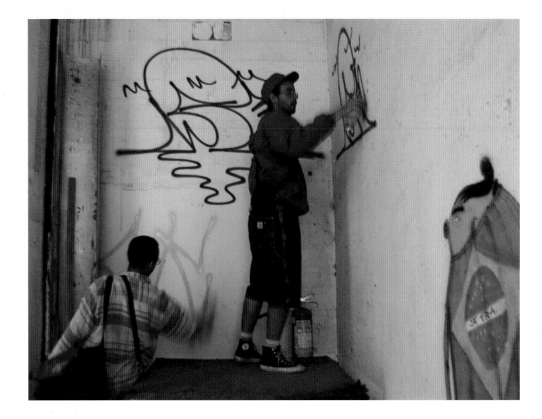

# Os Gemeos

With rage, bliss and the power of their simultaneity, Os Gemeos have come to signify Brazilian graffiti itself to many viewers. As twin brothers working together, Os Gemeos (which means 'the twins' in Portuguese) share a personal and creative bond equalled only by the relentless creative drive that fills each brother and spills over to impel the other still further. Their output spans every ramification of graffiti and street art from tag to epic mural, with an equal range and body of studio work. More than fifteen years after they began to paint in the streets, they are still among the most prolific and visible of São Paulo's painters, with a fearless approach to painting in blatantly illegal spots and with risky subject matter.

Their work ranges in tenor from lyrical and touching portraits of their beloved family to the gut-wrenching images of São Paulo's homeless, crippled and forgotten. Their sardonic political images of looters, terrorists, criminals and politicians collide an absolute despair for the inhumane world with the immediate, empowering agency and humanity of painting in the street. The brothers mine Brazilian folktales, literature, and their own mutual family and world of fantasy for source material. They couple these broadly accessible, if not universally understood, sources with a wide range of lettering styles at times funky, intimidating, comical and organic. In their lettering, they draw stylistic cues from São Paulo's *pichação* movement as well as their years of painting graffiti rooted in the traditions of hip-hop. Their resulting body of work continues to challenge, redefine and show what is truly possible with paint in the streets – regardless of whether the product is called graffiti, street art, murals or just art itself.

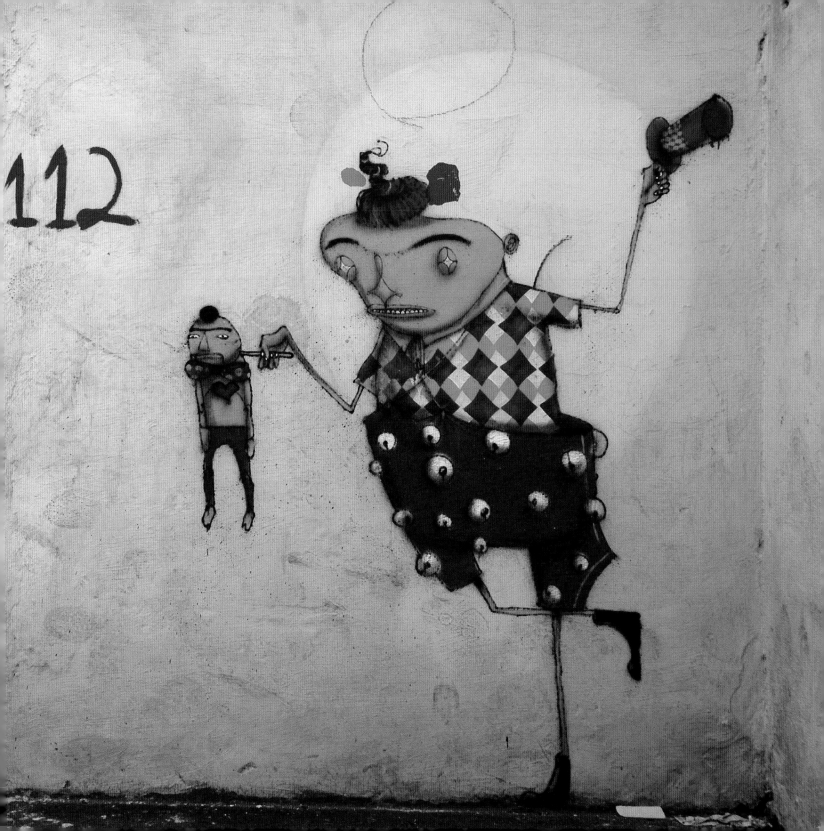

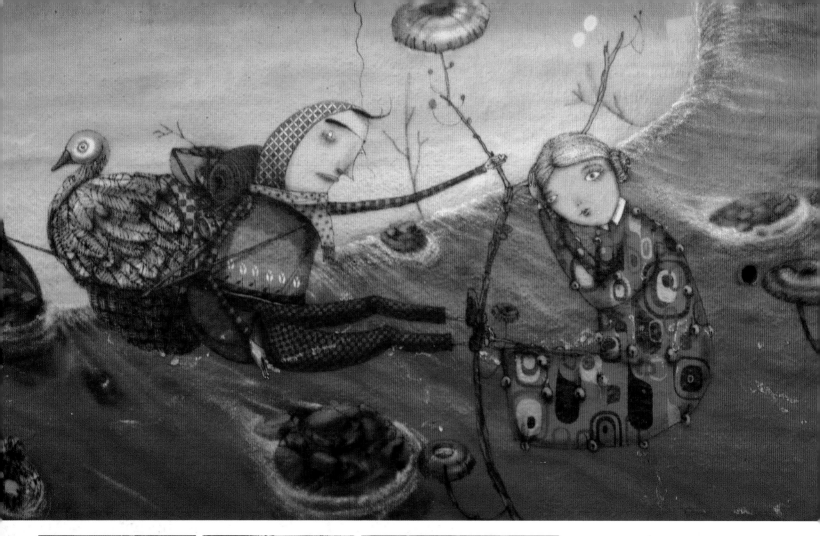

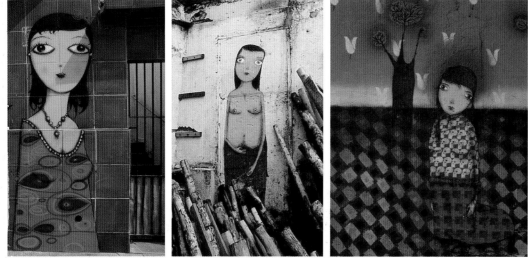

The costumed characters opposite (particularly top left and right, São Paulo, 2004) display some influences of Brazilian folklore, such as the *Bumba-meu-boi*, a northern Brazilian folkdance in which men wear ox costumes. One picture (bottom left) features writing ('The day it rained non-stop').

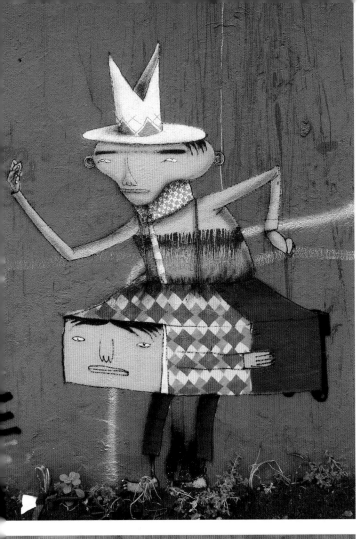
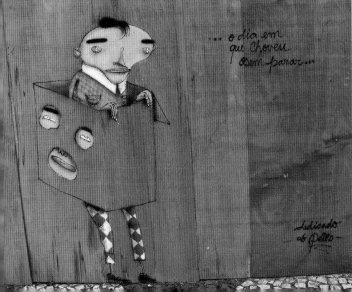
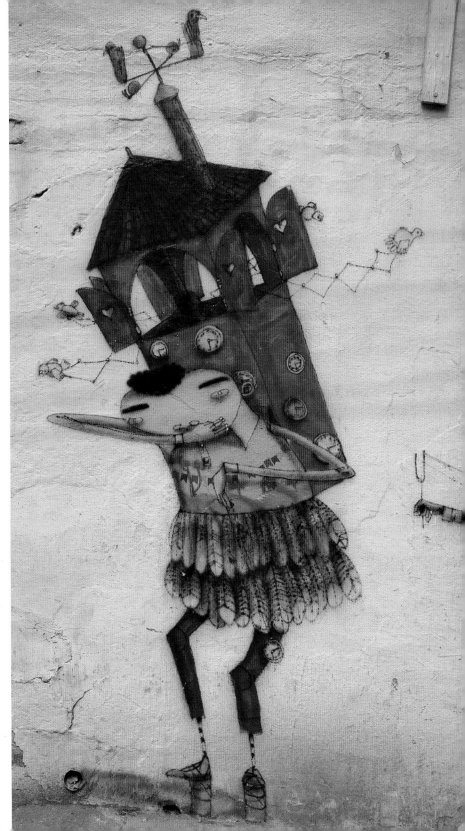

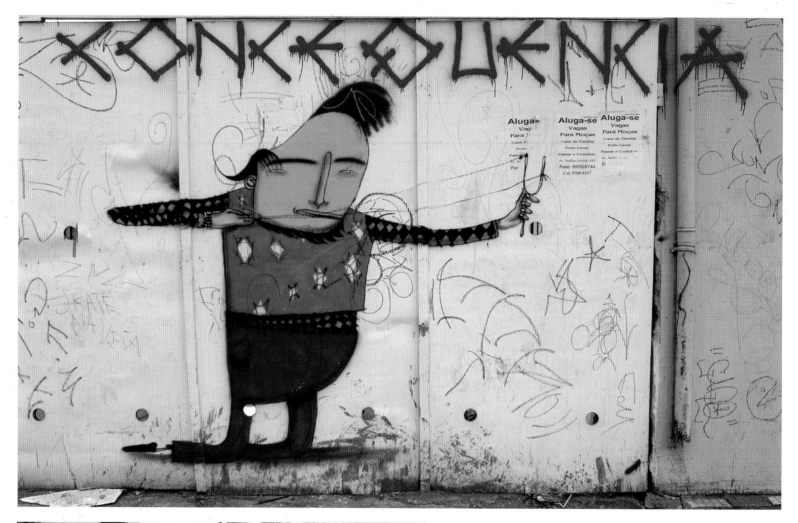

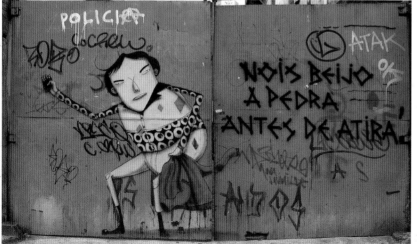

**Above** 'Consequences', São Paulo
**Left** 'We kiss the stone before we throw it', São Paulo
**Opposite** Rioters, robbers and terrorists, São Paulo

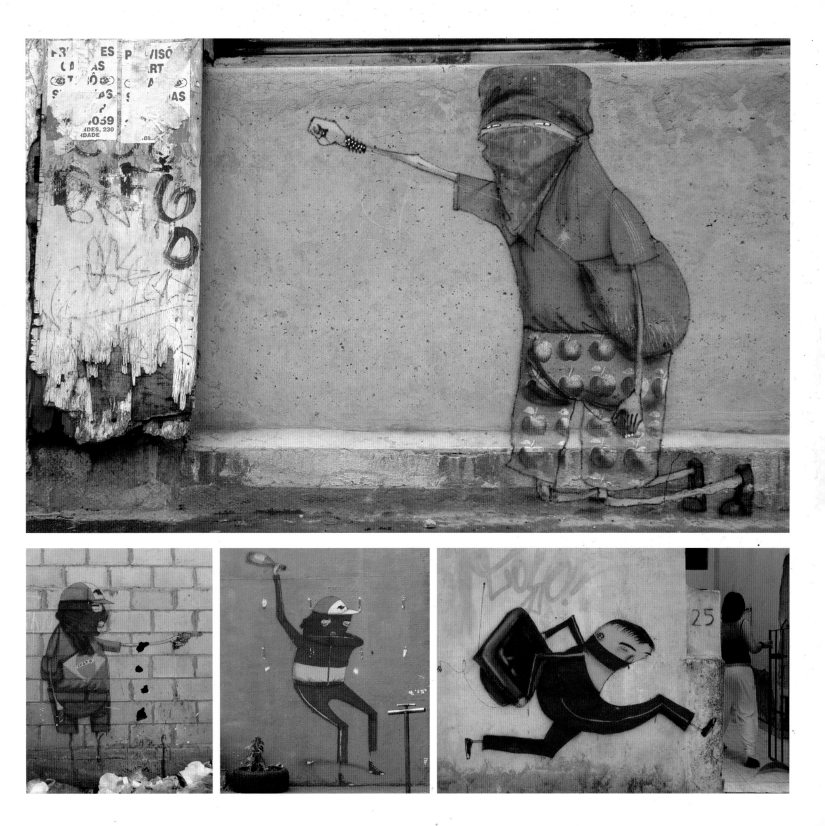

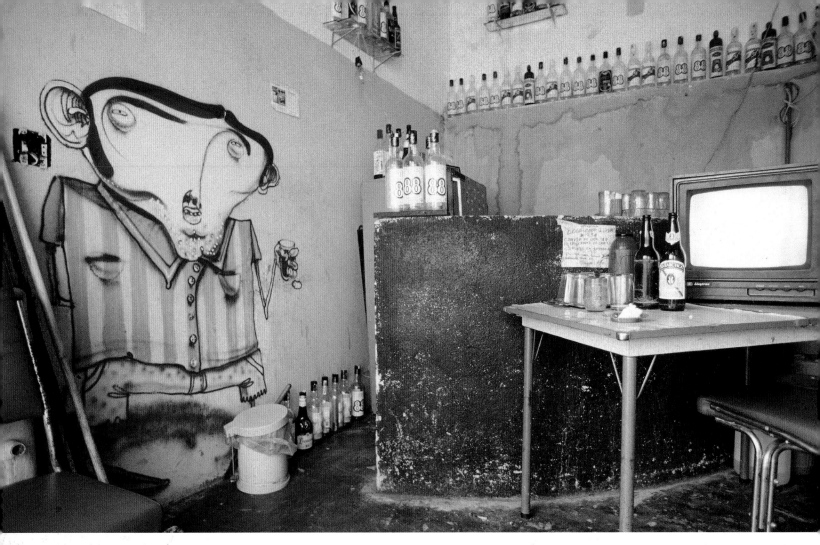

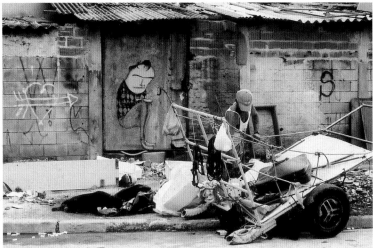

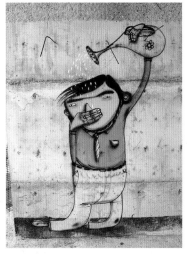

The picture above shows a mural of a local bar owner in São Paulo, which was commissioned and then subsequently painted over by the owner after it gave him nightmares.

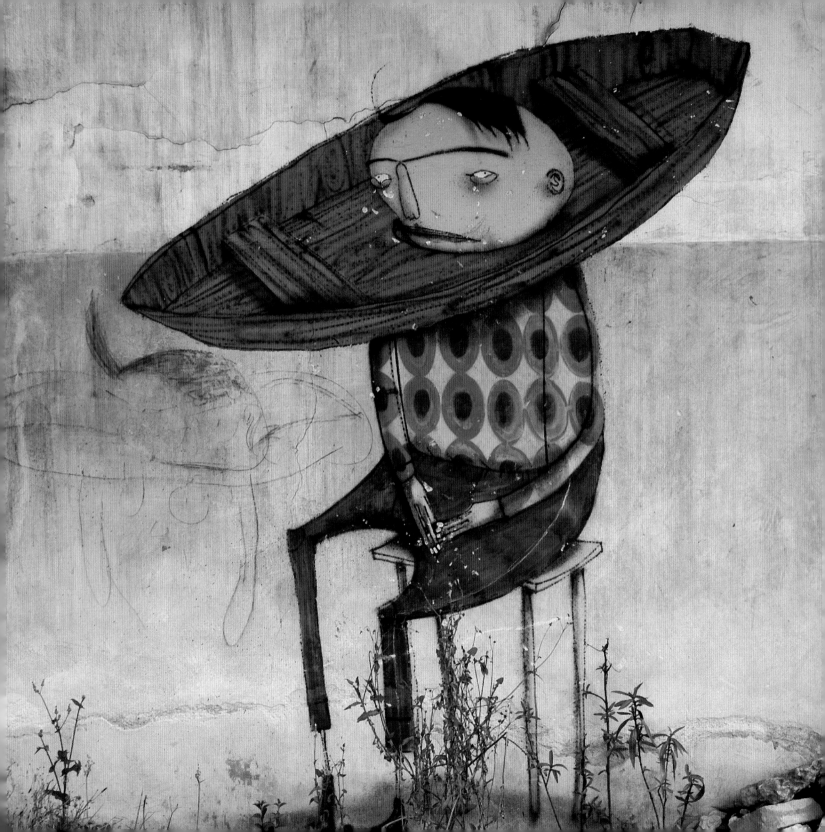

# Onesto

Onesto began painting in 1992 and is well known on the Brazilian scene for both his artwork and the graffiti videos he produces. His sketchbooks are packed with characters from all walks of life, taken from observation, mixed in with a dose of fantasy and humour. He doesn't bring his drawings with him when he paints but instead soaks up the local atmosphere, then does something on the spur of the moment. Observing day-to-day life is his inspiration: 'The Brazilian culture is very diversified and rich in details. No matter how much I look around, I always find fascinating new things. Sometimes they are small things, delicate or simple details which, applied properly, in the right place and right moment, make a difference to my work.'

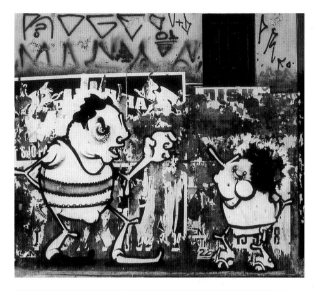

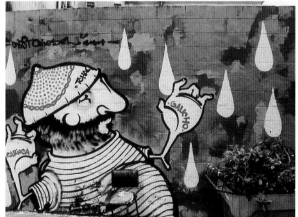

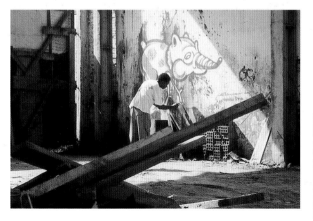

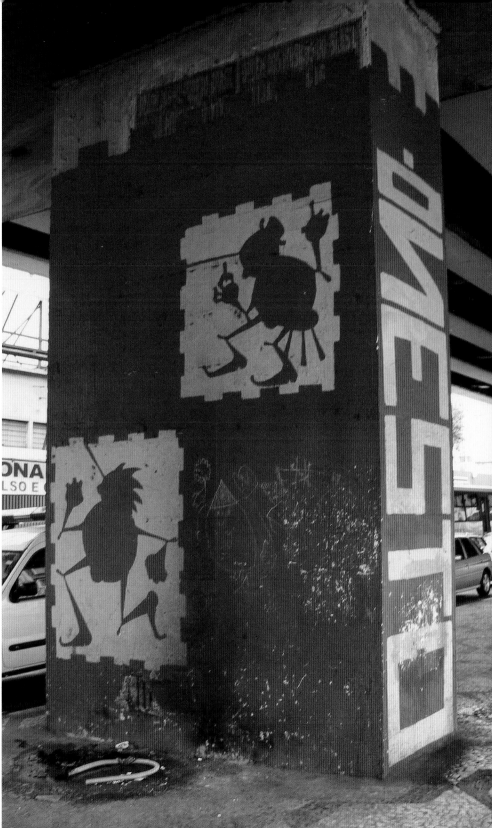

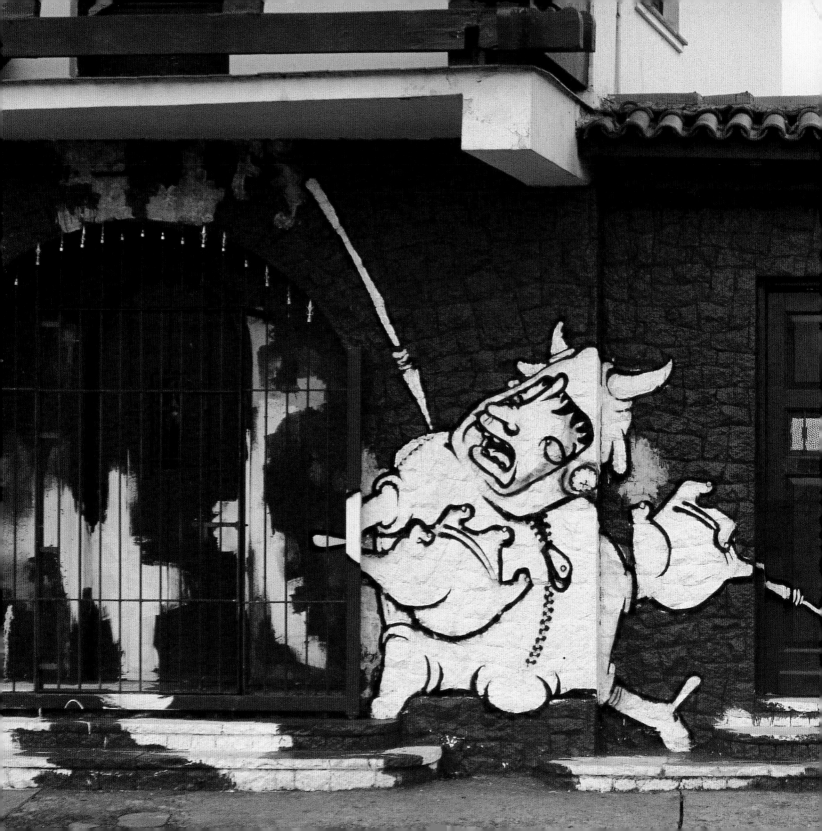

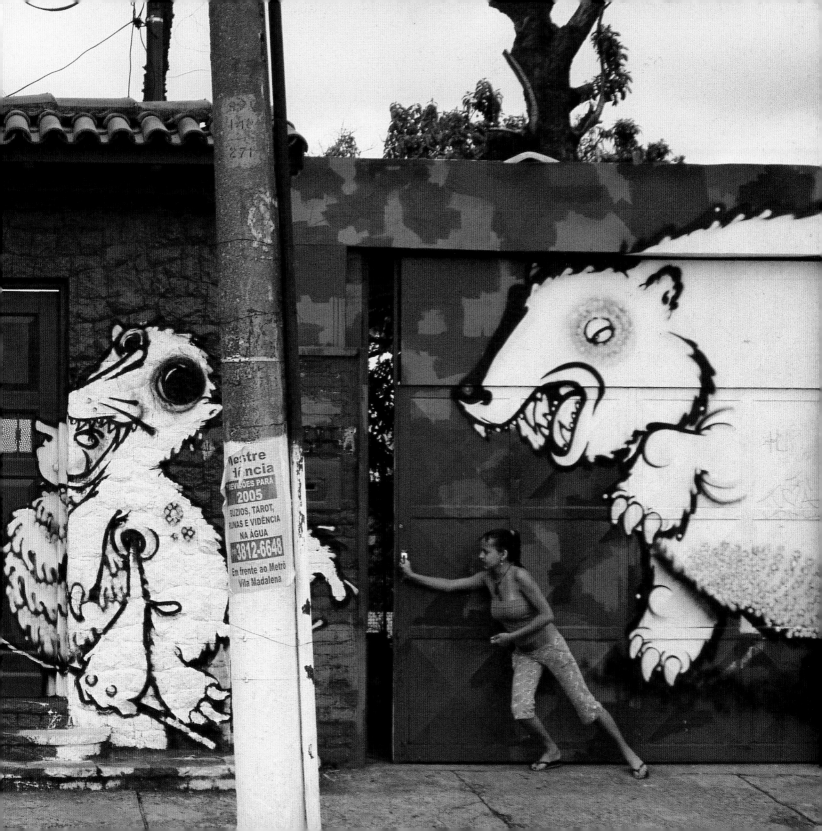

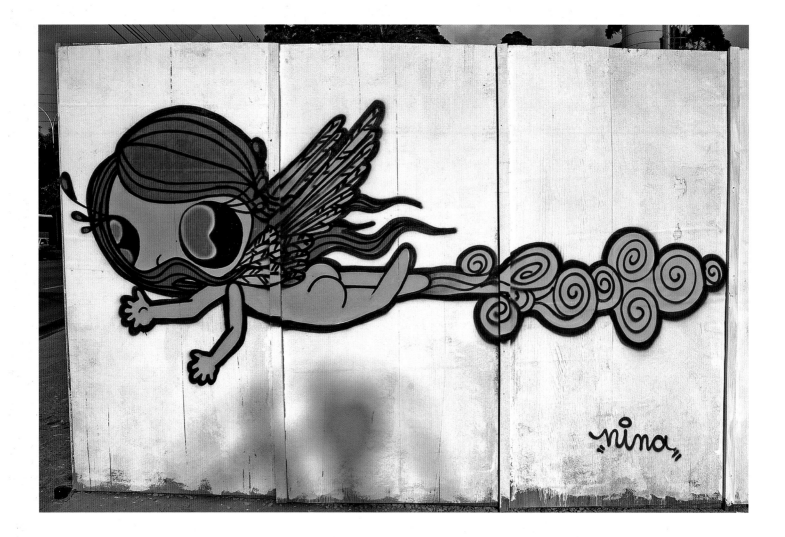

# Nina

Nina is an artist best known for her renditions of children and animals, painted in the street and rendered in studio form as paintings, clothing, dolls and stuffed animals. Her work is often deceptively simple in its execution, which brings the painted subjects to the forefront. In the case of her painted animals, this serves to underscore the irony present – how likely an encounter with a living animal would be in the gigantic megalopolis of São Paulo, and how far behind the city has left the natural world. Her animal creations, with their gigantic eyes and friendly colours, carry a wonderful, edgy sense of being ever so slightly 'off', painted in all their unfamiliarity by a woman who has lived her life in a city of twenty-two million.

While her animals carry an air of unfamiliarity, Nina's painted girls address the viewer with the startling familiarity of the multitudes of children present in the city, this time with all of the edges smoothed and their eyes eerily Disney. She will often use her accessible paintings as a foil to her often recondite collaborators Os Gemeos.

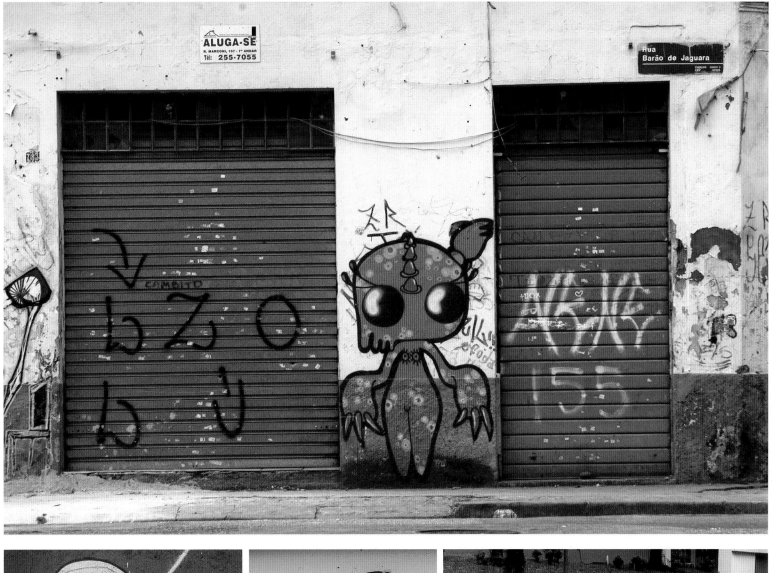

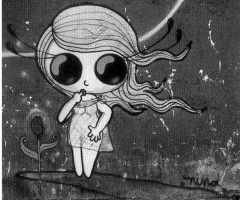

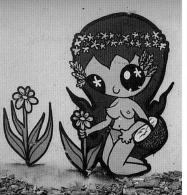

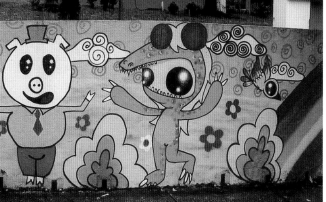

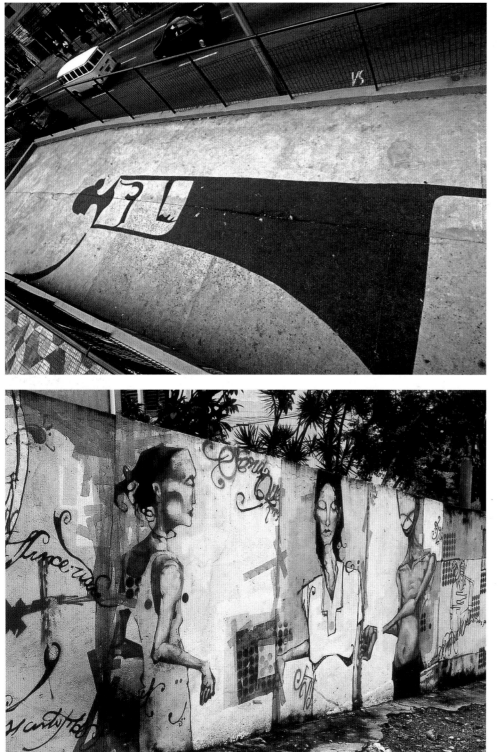
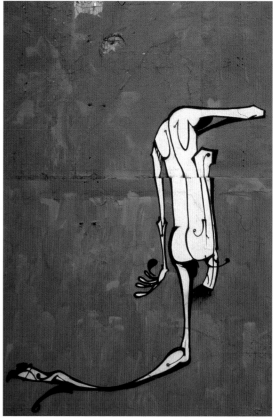
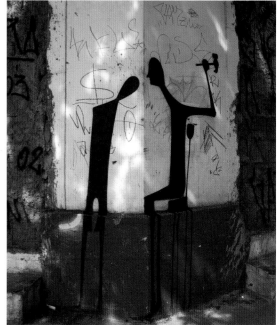

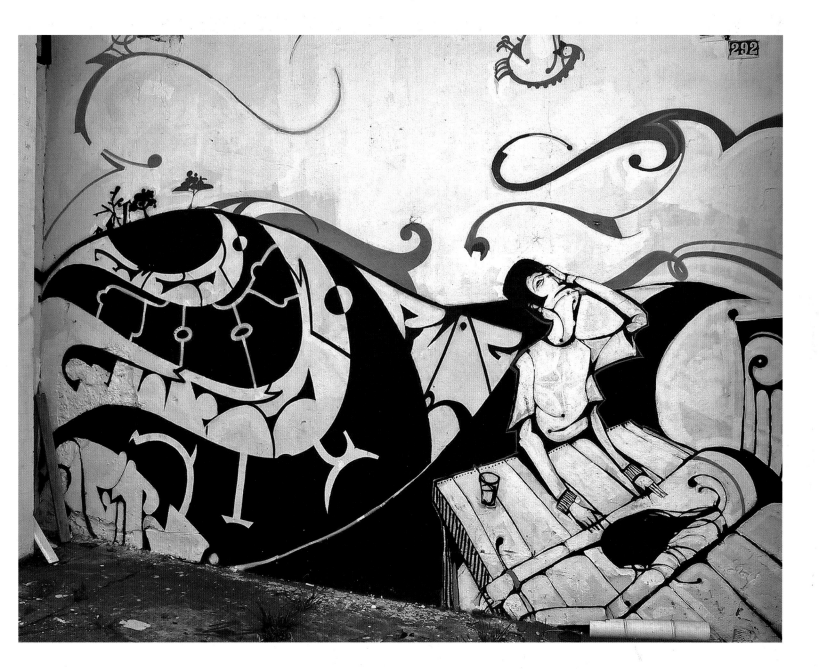

# Herbert Baglione

Herbert Baglione would prefer that his work be included in a cookbook.

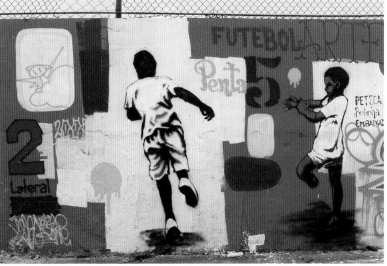

# Tinho

Growing up in São Paulo, Tinho was hooked on graffiti by the age of twelve. In 1987 he experimented with stencils but soon switched to New York-style spraycan art. By 1993 he began to develop a free-style approach using latex paint. This style change was a turning point for Tinho and for many other São Paulo artists, who saw it as the beginning of a new Brazilian school of graffiti.

His approach to painting is free spirited. 'They are all spontaneous and therefore they are not all good,' he confesses. He begins by painting a base for his pictures, picking colours and shapes that complement existing marks on the wall. The result is a collage of elements, including words, patterns and figures. American Pop artists have influenced his work, as well as Jean-Michel Basquiat, Edward Hopper and Gustav Klimt. His sketchbooks are filled with drawings taken from life, people and urban scenes, which he includes in his graffiti. 'Every artist paints what he lives,' says Tinho, and therefore Brazilian graffiti reflects artists' lives and experiences. Being of both Japanese and Brazilian descent has given him a different artistic perspective, he says.

**Above top** Tinho with Adam Neate and Waleska, São Paulo, 2005 **Opposite** Tinho and Adam Neate, São Paulo, 2005

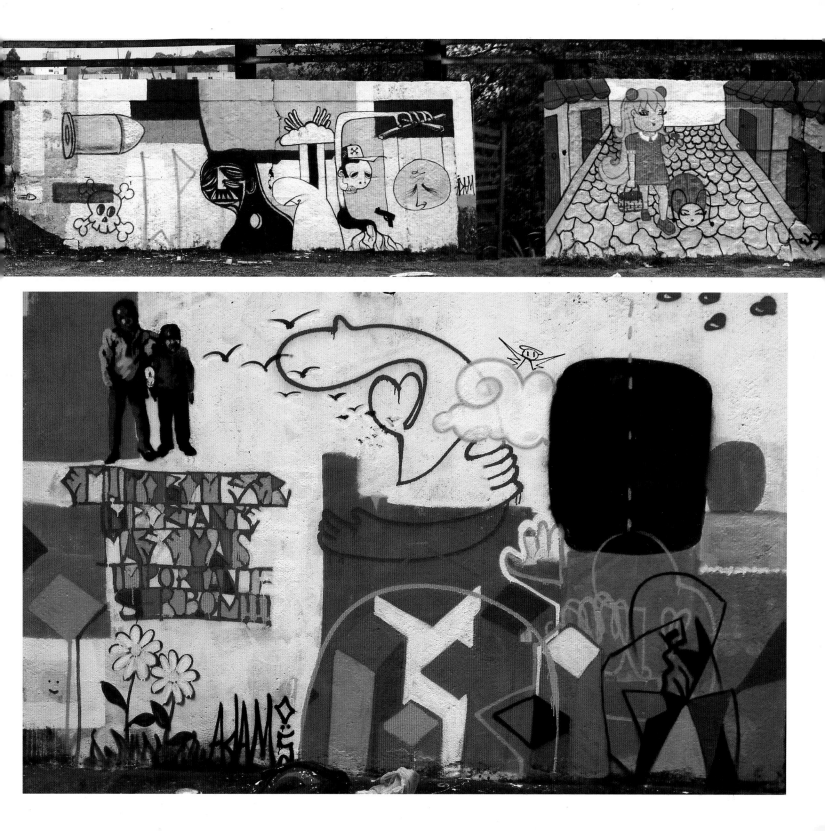

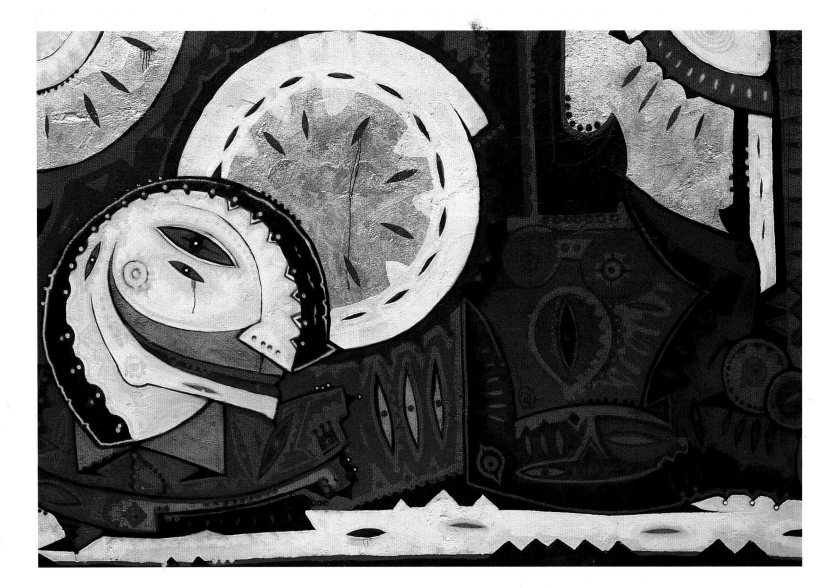

# Vitché

As a little boy working away in his bedroom, Vitché made drawings and used the results as toys with which to play and construct stories. He created characters with unique histories and traits through which he acted out the narratives of his imagination. Many years later,

with a refined style, a signature palette of red, black, white and silver, and more than fifteen years' experience of painting in the streets, Vitché still pursues the same mission. His street and studio work – which includes sculptural ex-voto figures in wire, wood and

other media – centres on ornately patterned characters, often representing warriors. Each character created has its personal story, one inevitably opaque to the viewer unless Vitché himself is there to narrate it, but impelling the form with a story and a journey nonetheless.

**Opposite top** Vitché with Herbert Baglione, São Paulo **Opposite, bottom left** Vitché with Jana Joana, São Paulo, 2004

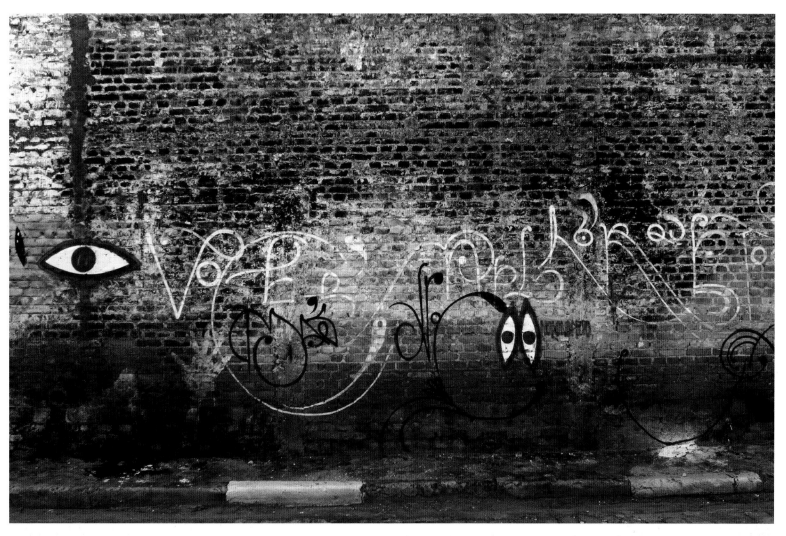

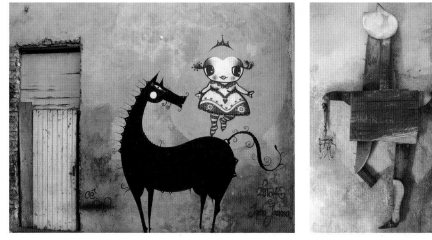

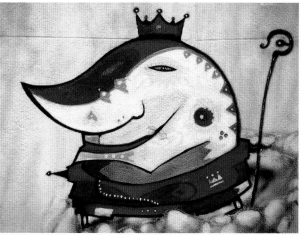

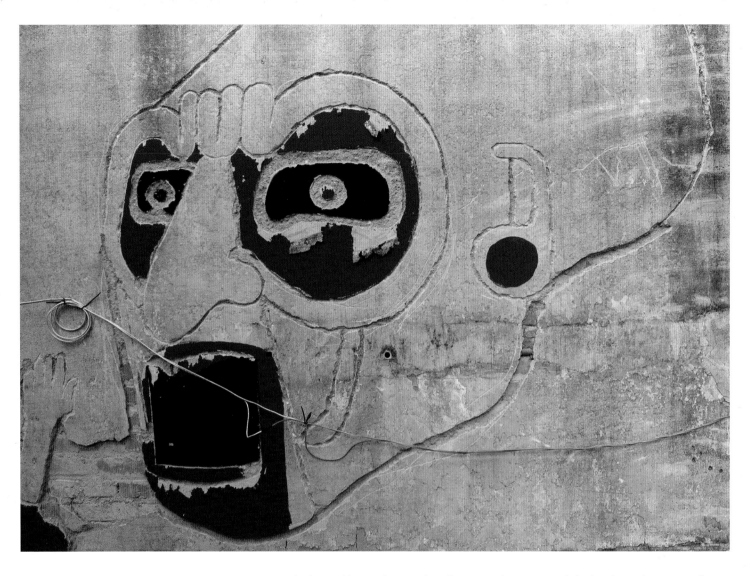

# Nunca

Nunca, meaning 'never' in Portuguese, started painting in 1992 and is now one of the rising stars of São Paulo's graffiti scene. His latest work juxtaposes urban and native cultures by combining the geometric patterns and colours found in indigenous South American artwork with the linework of *pichação*. The resulting portraits of indigenous South Americans serve as a reminder, he says, 'that people in Brazil are also descendants of indigenous South Americans, and not just African and European people'.

One of his largest productions, under a bridge in the Liberdade district of São Paulo, depicted a cannibalistic scene with fearsomely decorated indigenous Amazonians. By depicting native peoples in the heart of urban Brazil, with six lanes of traffic driving by, he creates a visual culture clash that comments on the history of this nation. This portrayal is not meant to be a stereotype but is more symbolic than that, perhaps even a reference to the cannibalistic nature of Brazilian culture.

Globalization is an underlying issue in his work. His indigenous characters sometimes sport a spoof brand name – 'Naique', which is the local pronunciation of Nike. In homage to indigenous South American cultures, he has even adopted carving techniques in his graffiti. One example is a Mayan-style warrior engraved on the walls of an abandoned school, now a shelter for homeless children (see above).

**Opposite top** Head by Nunca and three suspects by Os Gemeos, São Paulo

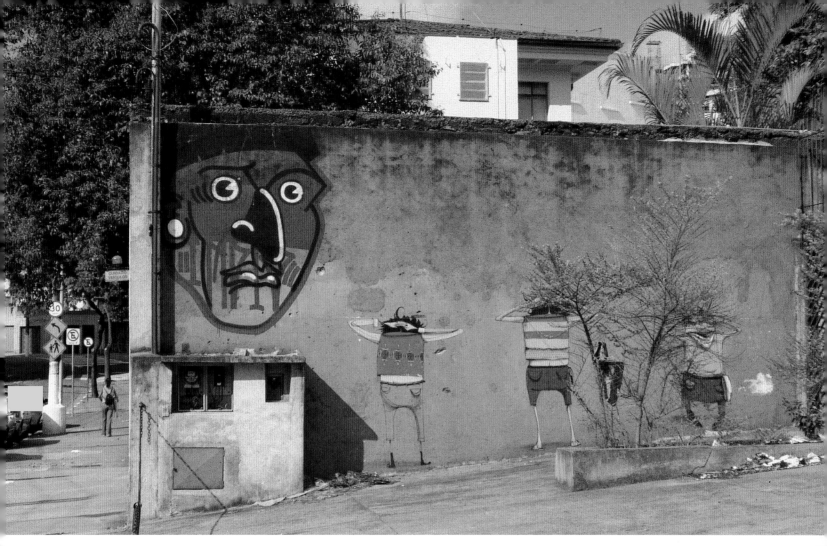

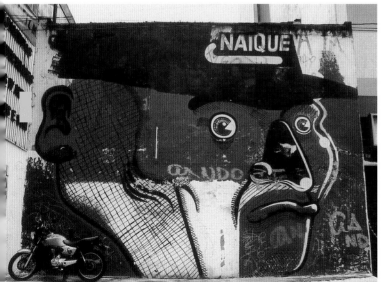

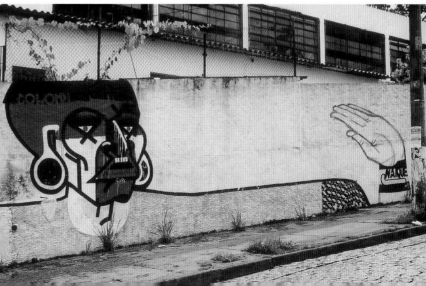

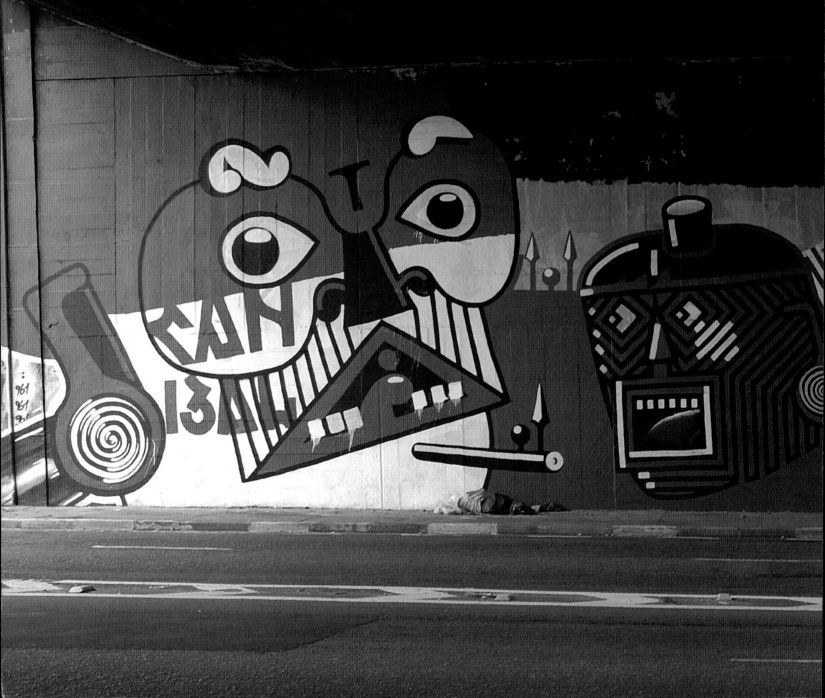

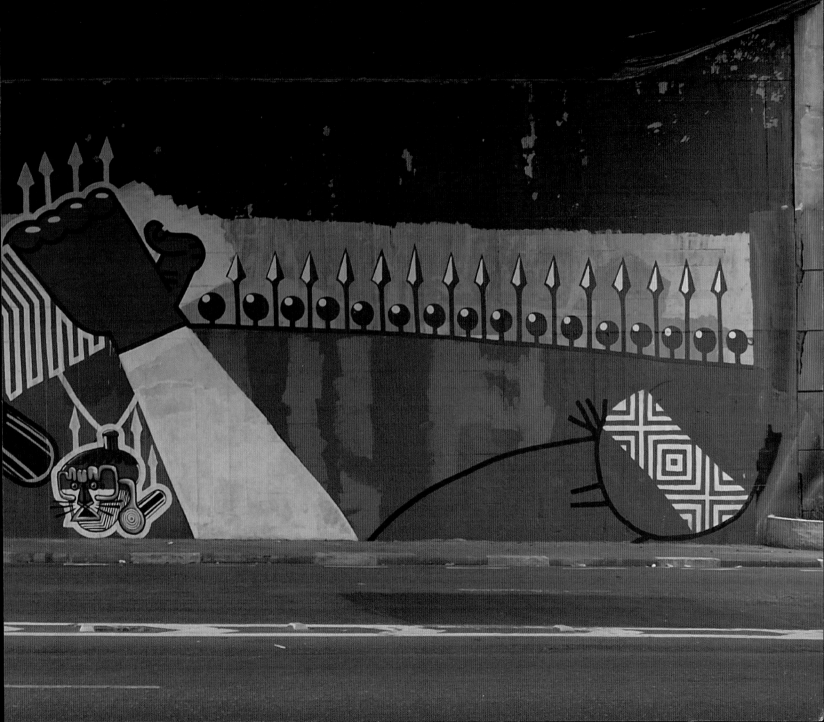

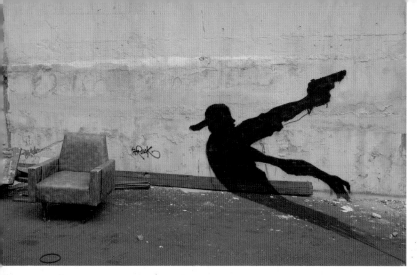
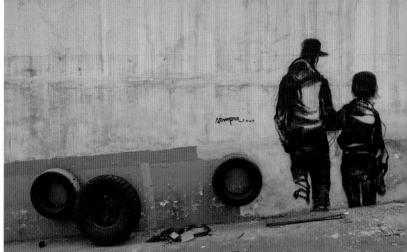
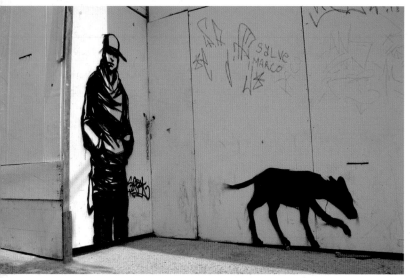
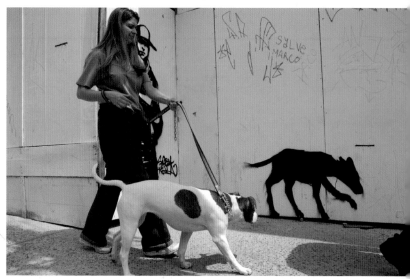
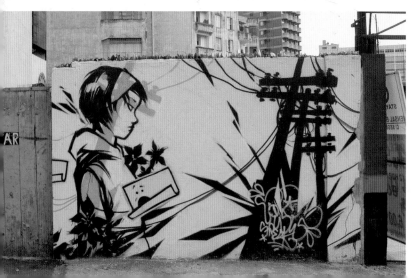
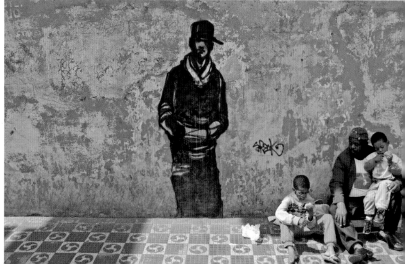

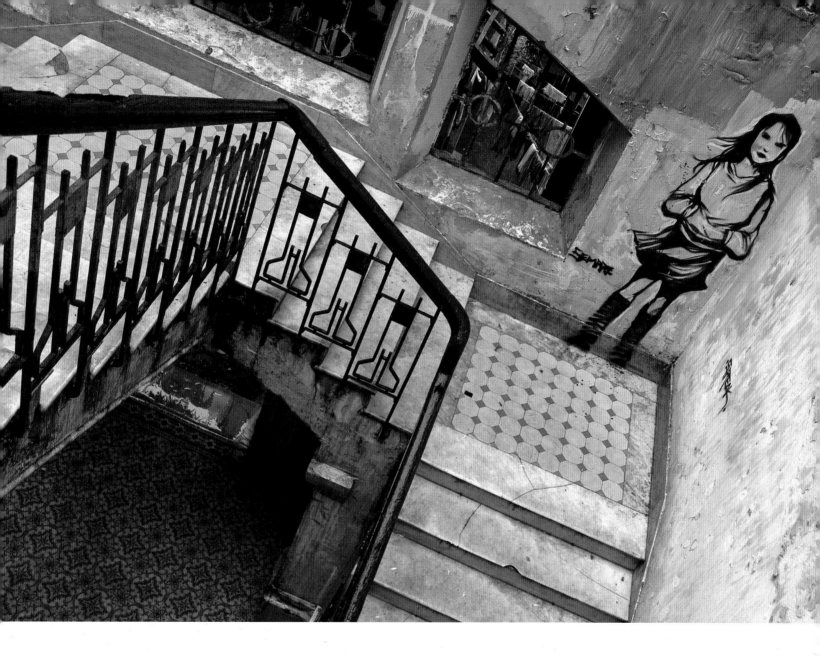

Titifreak is a well-known illustrator, graffiti artist and professional yo-yo champion. Before painting graffiti in 1996, his background was in comic art. He has collaborated with many other artists in big productions, but lately has been producing personal works mainly in his own district of Liberdade, São Paulo.

Although his work can be detailed, he strives for simplicity in his art, inspired by people and the spaces where he chooses to paint. The urban environment is always present in his energetic drawings, which include buildings, electric tramlines and other elements of city life.

# Titifreak

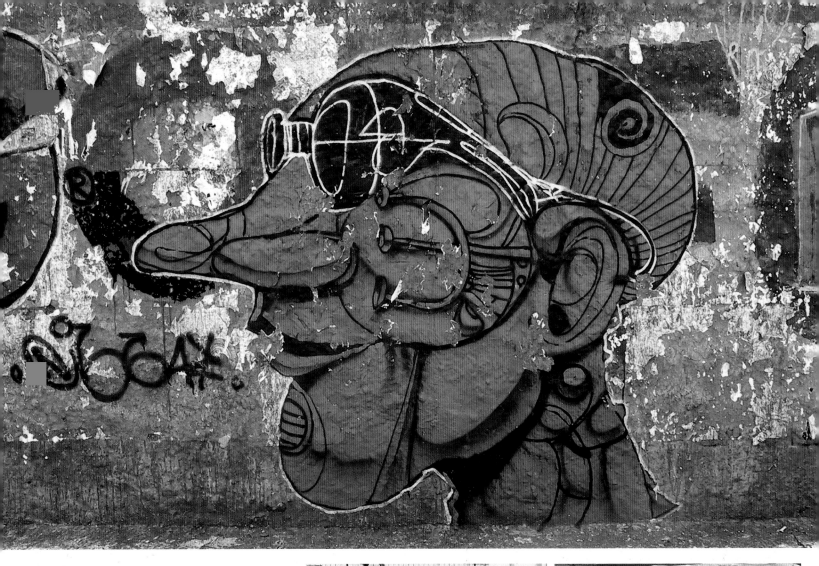

# Niggaz

Niggaz was a young artist well on his way to a special place in São Paulo's graffiti scene when he passed away in 2003. His figurative street works occupied spaces in the city from the busy Avenida Paulista to abandoned spaces in his neighbourhood, far from the city centre.

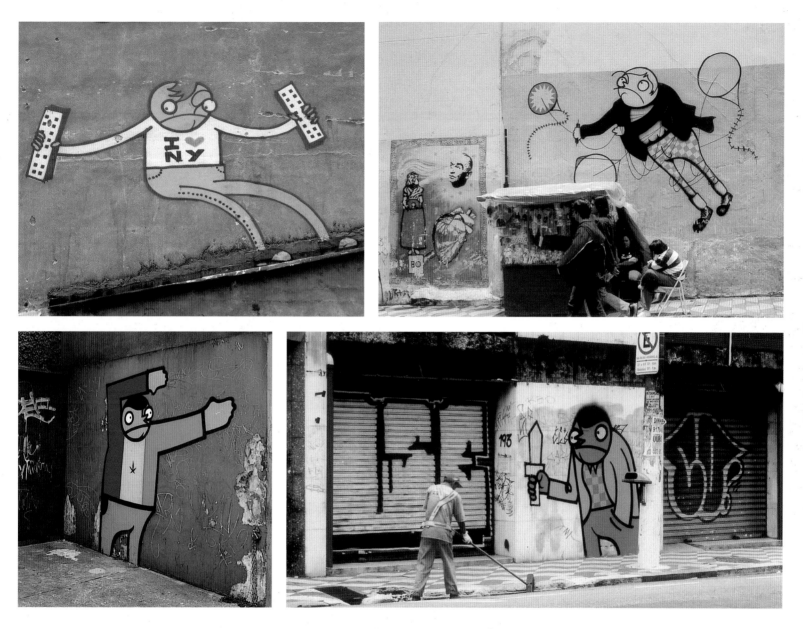

# Loucos

Loucos are a two-brother team hailing from São Paulo. Their work, normally a combination of green, white and black, has a decidedly youthful feel, often populated by images of young boys flying kites, which is a constant sight in Brazilian cities. However, like the kites, which are used as fighting toys that cut each other's paper sides apart with strings rolled in ground glass shards, the youthful glee of Loucos's work sometimes belies its grit and edge: Loucos's throwups can be found above the crowd in many brazenly illegal spots, and their attention to lettering design shows their respect for and influence from the *pichação* tradition of São Paulo.

**Bottom right** Character holding a sword by Loucos, with letters by Ise and Coio, São Paulo

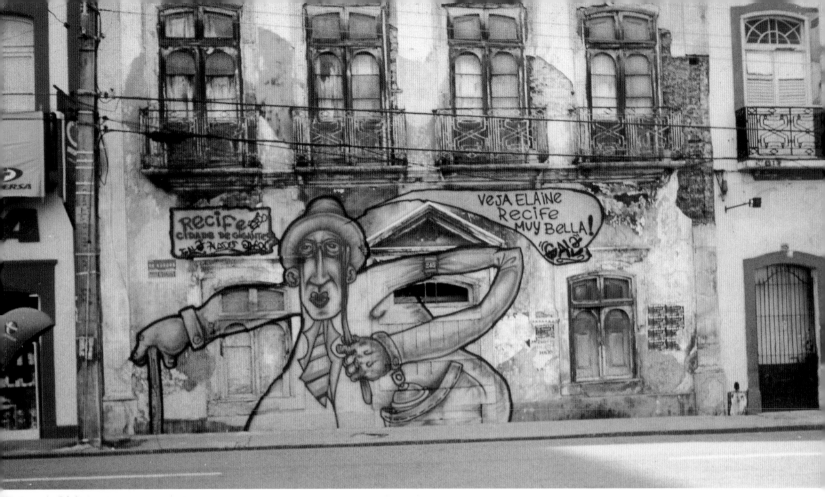

**Above** Exito d'Rua Crew, Recife, 2001
**Bottom left** Unknown artist, São Paulo
**Bottom right** Unknown artist, São Paulo

Opposite
**Top left** Ducontra, São Paulo
**Top centre** Unknown artist, São Paulo
**Top right** Tikka, São Paulo
**Centre left** Traços, Santo André
**Centre right** Unknown artist, São Paulo
**Bottom left** Paulo Ito, São Paulo
**Bottom right** Unknown artist, São Paulo

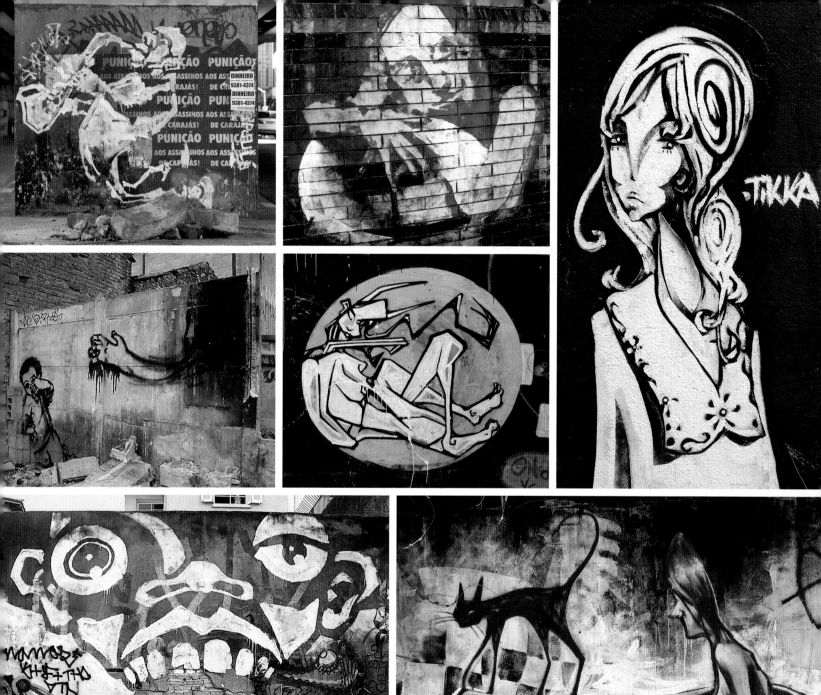

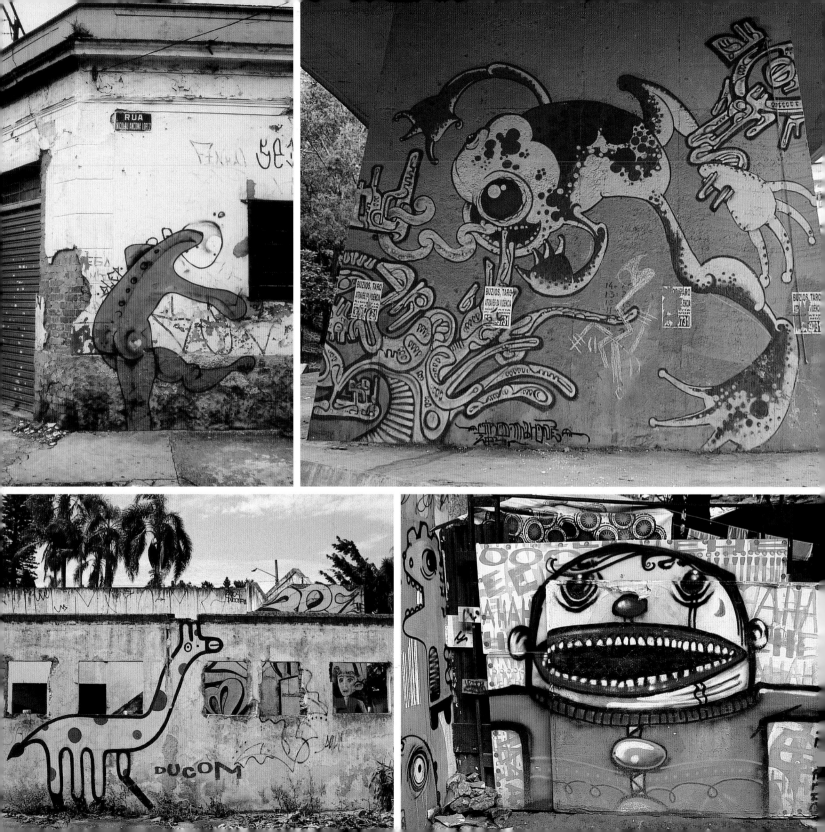

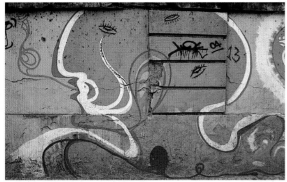

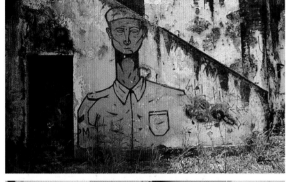

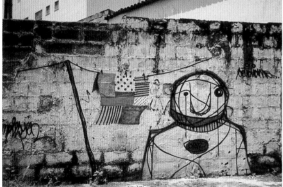

Opposite
**Top left** Unknown artist, São Paulo
**Top right** Onesto with Ciro, São Paulo, 2004
**Bottom left** Sapo, São Paulo, 2004
**Bottom right** Jey and César, São Paulo, 2004

**Above top** Pontogor, Rio de Janeiro, 2004
**Above centre** Daniel Melim, São Paulo, 2004
**Above bottom** Cimples and Syen
**Right** Unknown artist, São Paulo, 2004

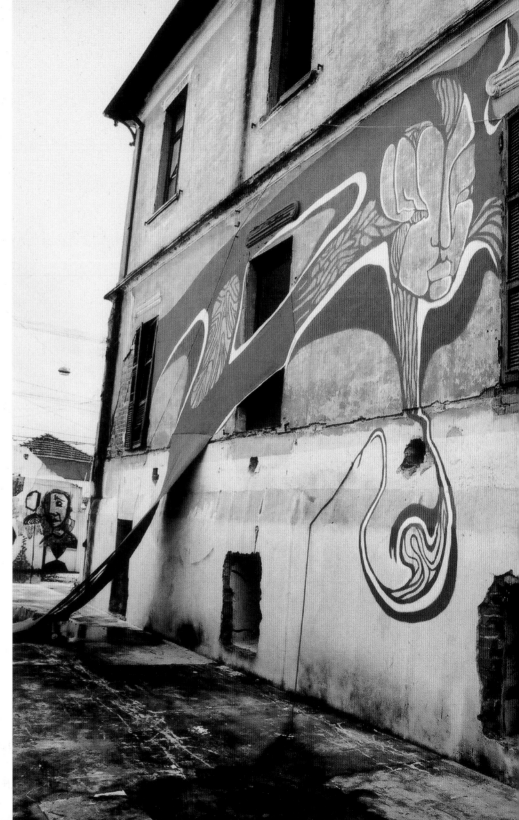

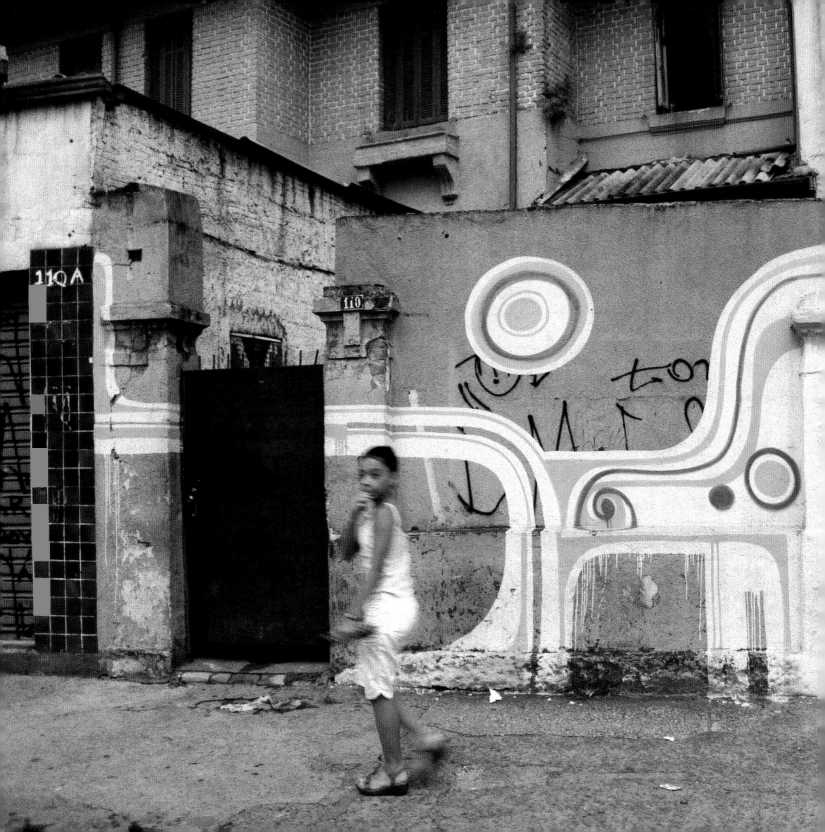

# Abstract Graffiti
## (*Graffiti abstrato*)

In Brazilian graffiti there is a distinct trend towards abstract forms. The emphasis is on colour, form and shape rather than words and figures. Since New York painter Futura 2000 began to abstract letter forms and explore spraycan techniques in the early 1980s, artists have continued to explore this in graffiti. What makes abstraction in Brazil intriguing is that it's done with a whole different set of references and inspirations.

One group of artists from São Paulo who paint organically are Tchais, Highraff, Ciro, Zezão, Boleta and Prozak. They often collaborate together, taking their influences from natural forms and psychedelic patterns. Like tropical plants, their collective designs weave themselves into the city walls, reflecting the energy and chaos of Brazilian nature. Highraff describes the painting method: 'The process is more intuitive than rational…choose good places and a good combination of colours and start painting freely, no sketches…let it flow like music…if you paint with someone else, it's like a telepathic jam session….'

Among the colour explosions and visual meltdown of the group work, each artist has his own noticeable motifs and influences – for instance, Zezão's fractal colour mixes, Boleta's melting birds and Highraff's organic shapes. Ciro and Prozak also combine figures and faces in their designs.

Outside São Paulo, other artists have also been working with abstract patterns, including Kboco from Goianas and Dalata from Belo Horizonte. Each artist's inspirations are varied: Kboco has a particular affinity with tribal designs in his strong use of decorative lines and totem-like characters, while Dalata's work is reminiscent of Surrealist painters such as Joan Miró.

Productions can be completely abstract, with each artist's work intertwining, but often letter forms and characters are also introduced into these dynamic and fantastical compositions. Strange juxtapositions occur as figures interact with free-form shapes. For many of these artists, painting abstract forms is a development from years of painting more traditional graffiti letters, characters and even *pichação*.

In Brazil, there is less stratification in the styles people paint and less of a hierarchy of who paints with whom. Graffiti is a social activity as much as anything else, and so mixing styles is part of the fun.

Many artists who are known for their free-form styles are just as talented when it comes to figures or lettering and so sometimes switch approach depending on the piece. Beyond the bigger productions, artists explore the contours and spaces of the city using the language of shape and colour that they have developed.

Kboco, São Paulo, 2004

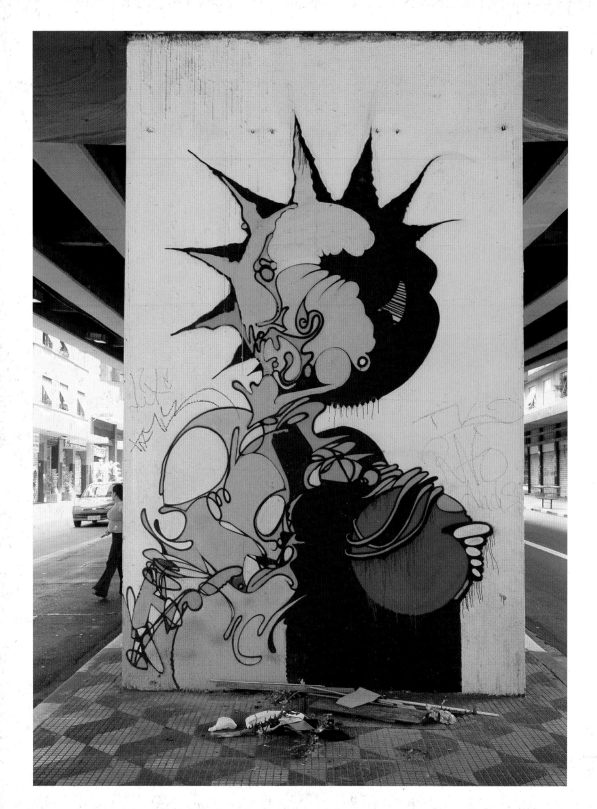

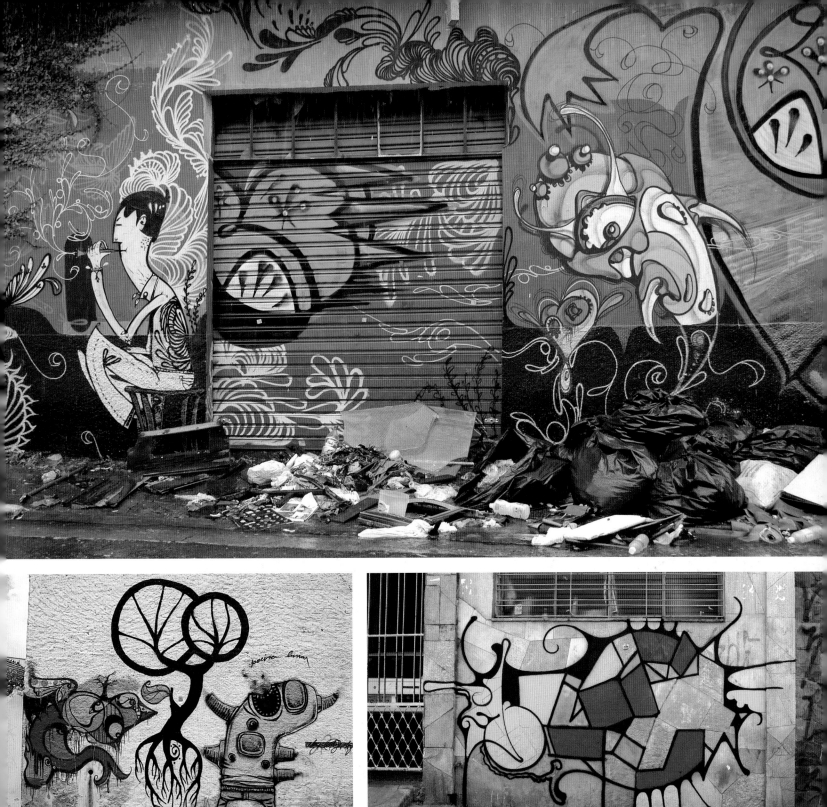

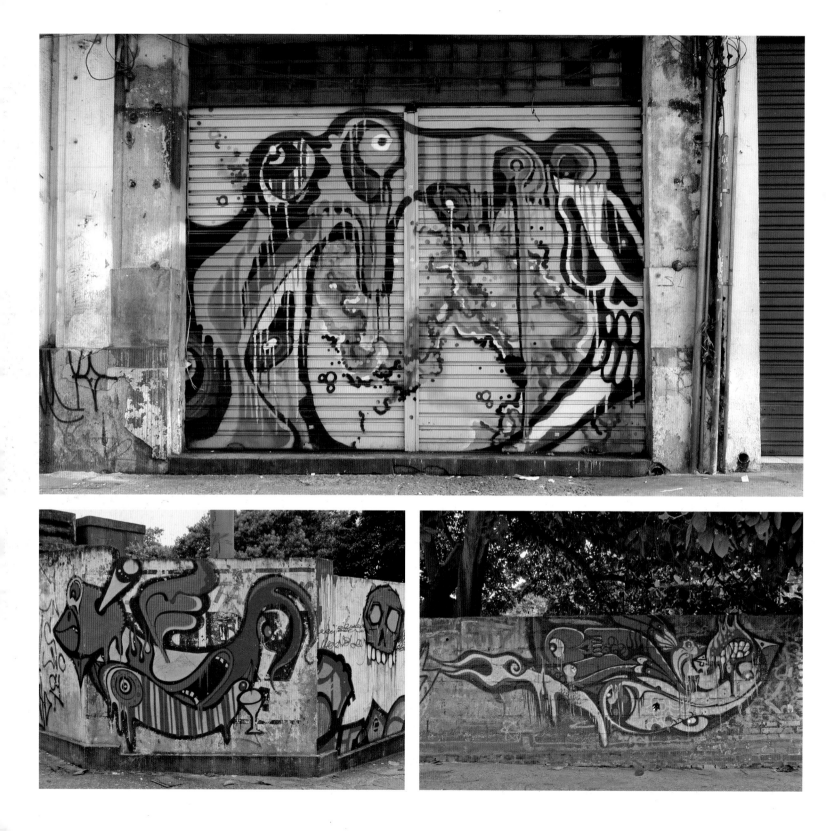

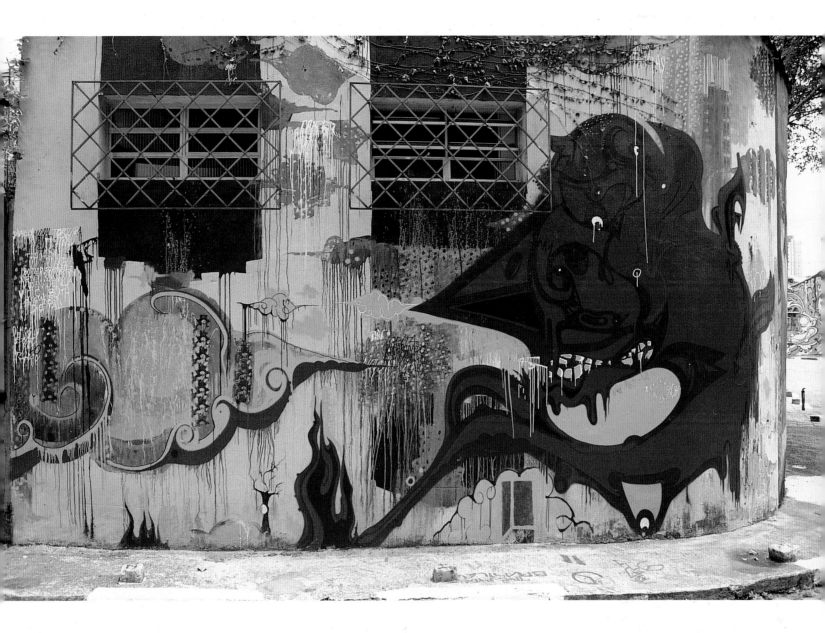

São Paulo artist Boleta began his street work as a *pichador* in 1989 as a young teenager enamoured with the idea of working in the street. He slowly branched out into graffiti in the mid-1990s, first with throwups and decidedly letter-based work. Over the past few years, he has abandoned lettering in his elaborate, dripping compositions, and focused on abstracted shapes based on bird forms. His work has developed in this way without abandoning *pichação*, in which Boleta still participates, despite success in fine art and the experience of night-time heroes forcibly playing Russian roulette with him on São Paulo's streets.

# Boleta

**Opposite top** Boleta and Zezão, São Paulo, 2004 **Opposite, bottom left** Boleta and Jeyone, São Paulo, 2005

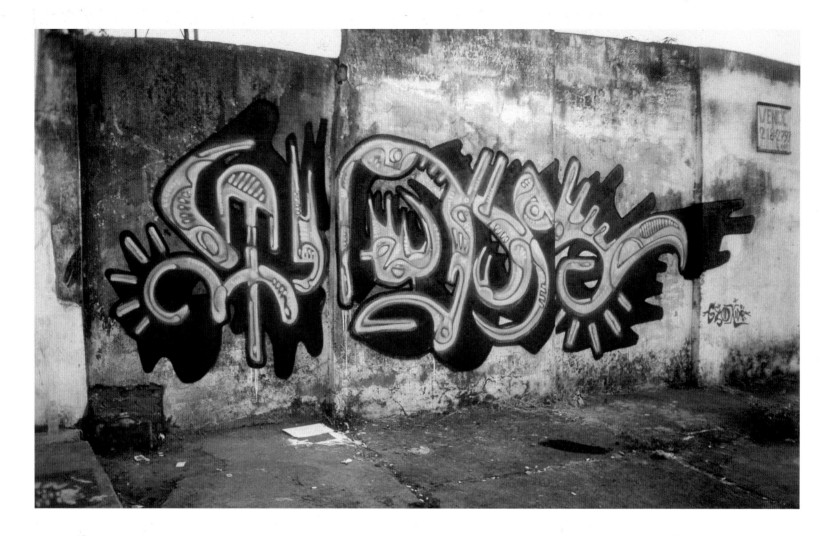

# Ciro

Ciro started painting in the city of Santo André in 1994. He began with 'traditional graffiti', but over time developed his own style of painting with forms inspired by the indigenous ethnic arts of South America and Africa. He is fascinated by the spiritual nature of ethnic arts as well as the shapes used in tribal patterns. Sometimes his work includes figurative elements, and at other times it remains expressively abstract.

Before painting, he first looks at the space to see the possibilities of interaction. He then creates shapes with latex paint and finally works into it, making fluid contours with spray-paint. 'I don't like getting there and changing the scene,' Ciro explains. 'I try to add something to it, starting a dialogue and an interaction.... The city has an atmosphere that is conducive to a multitude of possibilities (not only to

paint)....The city changes into a fairground for me because it puts me in touch with its diversity. It takes me away from the routines and feeds me spiritually, mentally and visually. Without that, my life would be mediocre. To paint in the streets is something religious and sacred for me. I don't paint thinking about other people or to please them. I firstly paint to relax and to reflect about my life.'

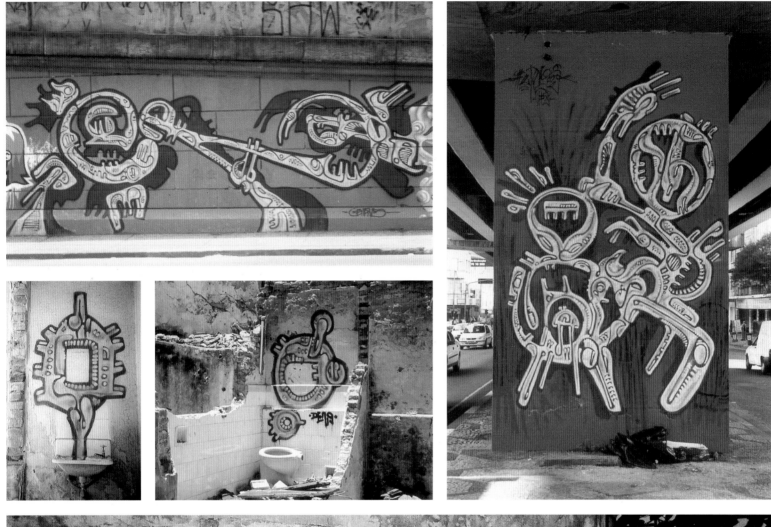

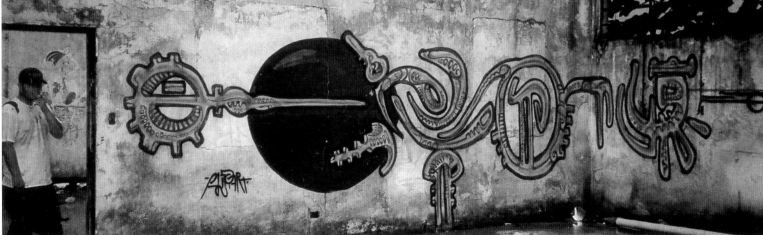

# Zezão

Among the many graffiti artists in São Paulo, Zezão has gone to the greatest lengths and depths to make his mark on the city. Zezão paints prolifically in well-hidden places, from the abandoned ruins of the Carandiru Prison to the depths of São Paulo's sewers. Painting in the sewers is not for the faint-hearted, and proper equipment is essential. Undeterred by flash flooding or the risk of disease, Zezão has made the sewers his own personal world of exploration, with very few painters foolhardy enough to follow.

His work takes on several forms according to the location. In the sewers he paints organic shapes, which he calls 'flops', on the streets he sometimes paints *pichação*, and with bigger murals he has developed a colourful psychedelic style. His psychedelic designs are a typical story of Brazilian ingenuity: unable to afford spray-paint, he would make use of the last drops of spray in cans, which people would donate to him, to create amazing fractals of colour.

In a city that is often unforgiving, he makes art in the streets 'to leave his personal brand and feel like a part of this city that casts people away'. He hopes that, through his work, 'he can send good vibrations to all kinds of people in the street, especially the poor and the homeless, to send them some affection in their hard life'.

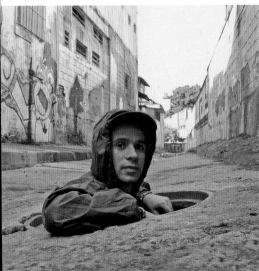

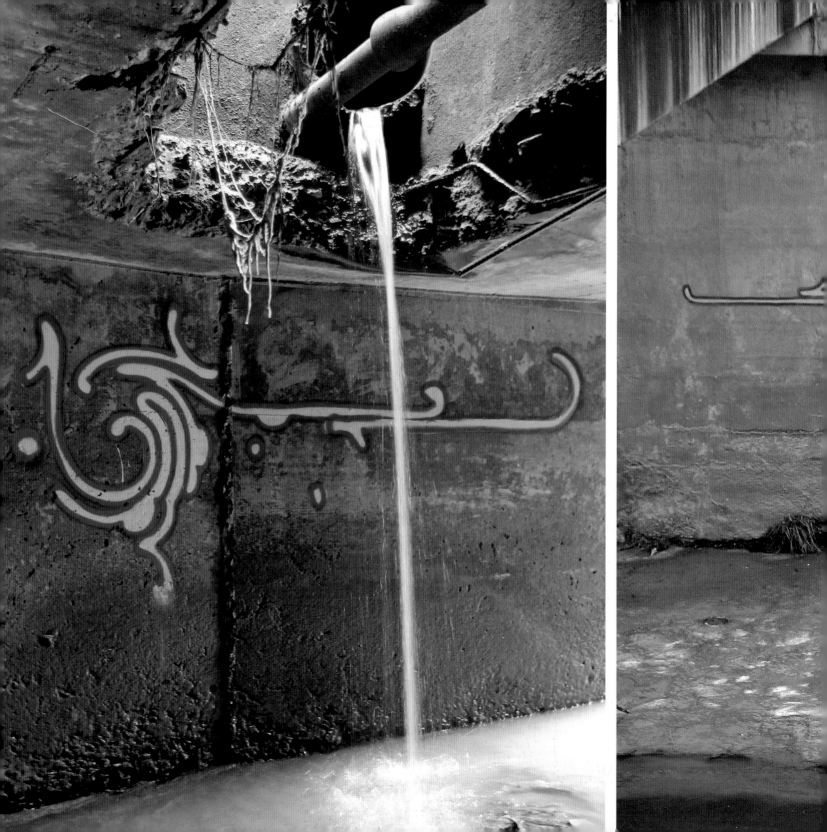

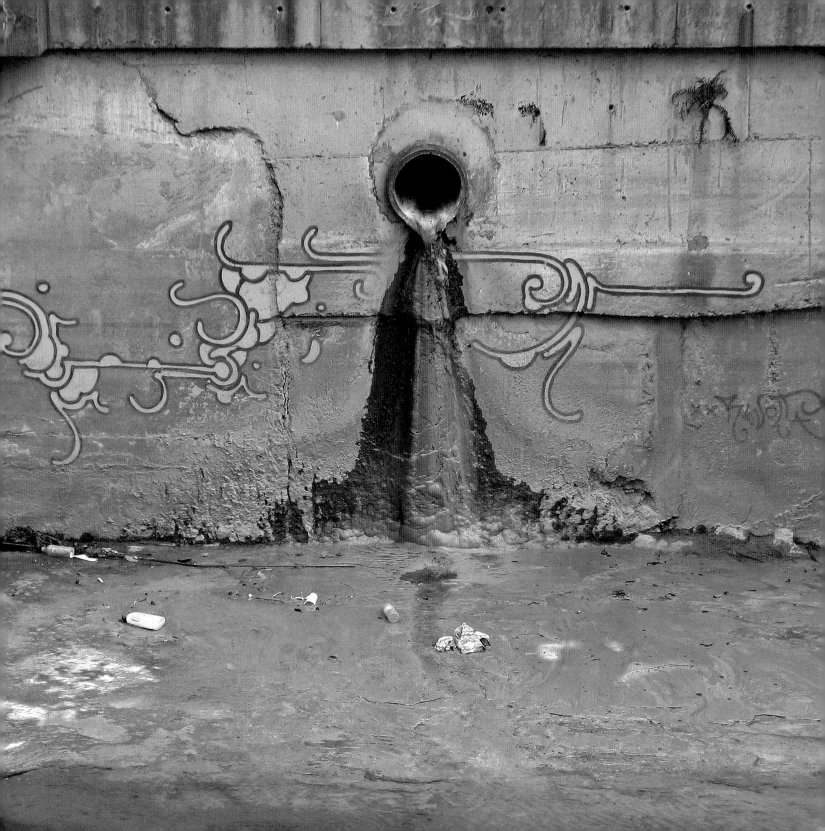

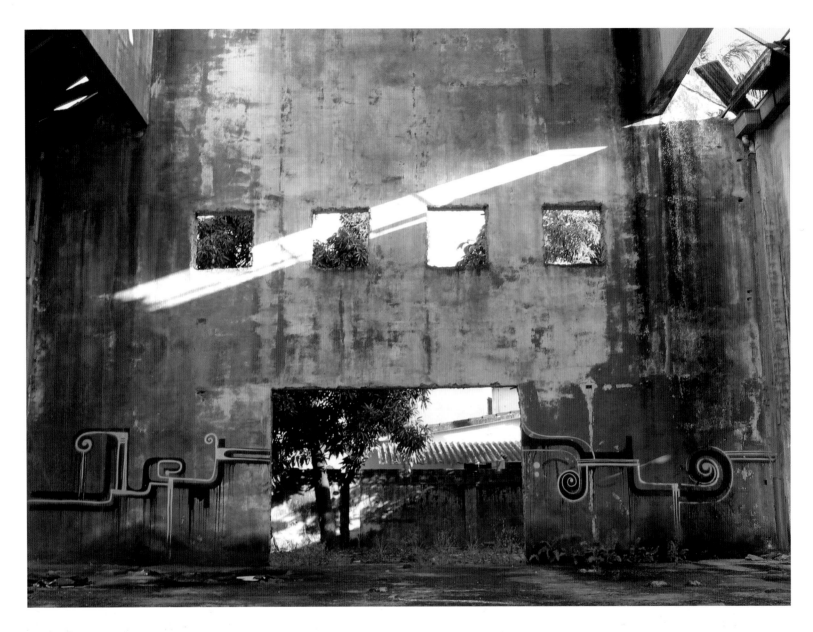

# Kboco

Kboco's hometown is Goiânia in the central high plains, but he is well travelled. His paintings adorn colonial architecture in the ports of Olinda and Recife, as well as vacant lots in Porto Alegre and São Paulo. Wherever he travels, his paintings adapt to the atmosphere of each city, often determining the mood of his work. His influences include African art, Mayan designs and native Brazilian artwork. From the world of modern art he admires Regina Silveira, Arthur Bispo do Rosario and Joan Miró. While his work is expressive, it is not solely abstract. Totemic figures, words and other motifs also feature in his fluid drawings.

Friends are an inspiration and an important part of the painting process for him, and for this reason Kboco is a great collaborator. In particular, he often paints with San One in Goiânia, Highraff in São Paulo and Trampo in Porto Alegre. Through his travels he has brought many artists together, establishing an extended family of artists across many cities.

**Opposite, bottom left and centre** Kboco and Trampo, Olinda, 2004

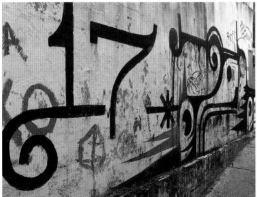

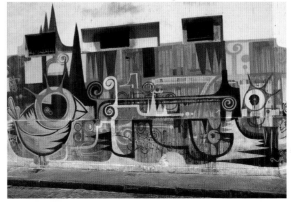

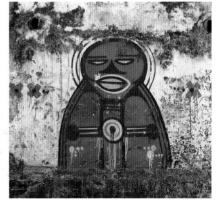

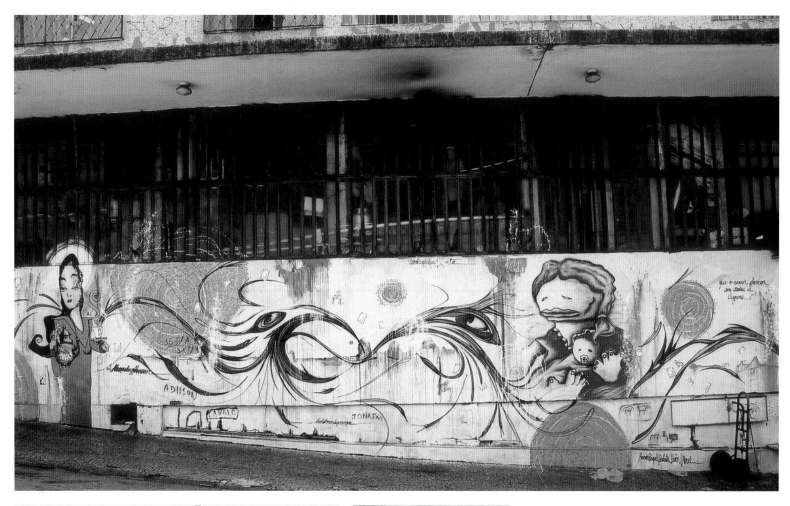

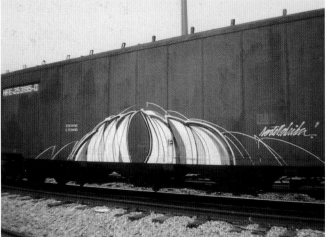

# Dalata

Dalata lives and works in the city of Belo Horizonte in the state of Minas Gerais. In comparison with Rio de Janeiro and São Paulo, Belo Horizonte is a small city, with a population of about three million. Dalata's body of work has centred on curvilinear arcs of colour suggestive of bird forms, to which he often adds eyes or mouths. However, his output frequently shifts in theme, occasionally working in portraiture and figurative work, more traditional graffiti styles, and alternative and experimental media in the street.

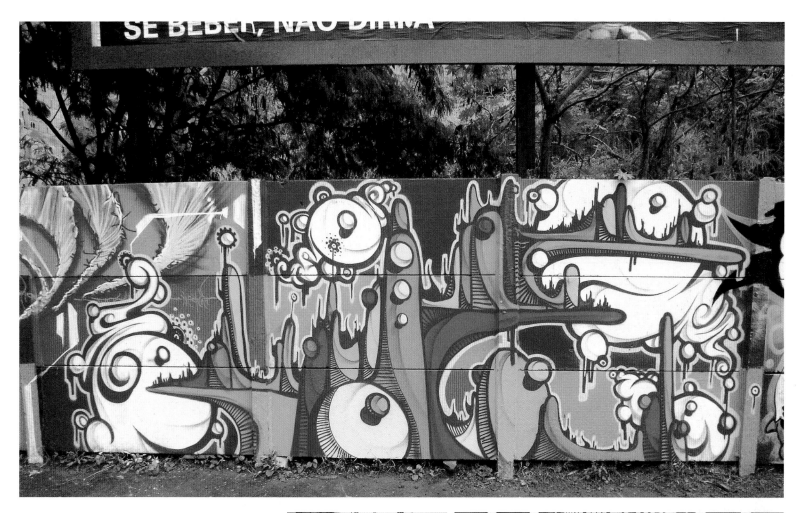

# Highraff

Highraff uses higher inspiration to transcend the language of graffiti to a new style of art, mixing illustration, comic language, psychedelic art and organic forms. A love for life and nature are some of the simple but profound motivations behind his exuberant style.

In the early days in São Paulo, working under the name Fuk, he was more concerned with bombing and painting trains. This period, he says, guided him to how he expresses himself today.

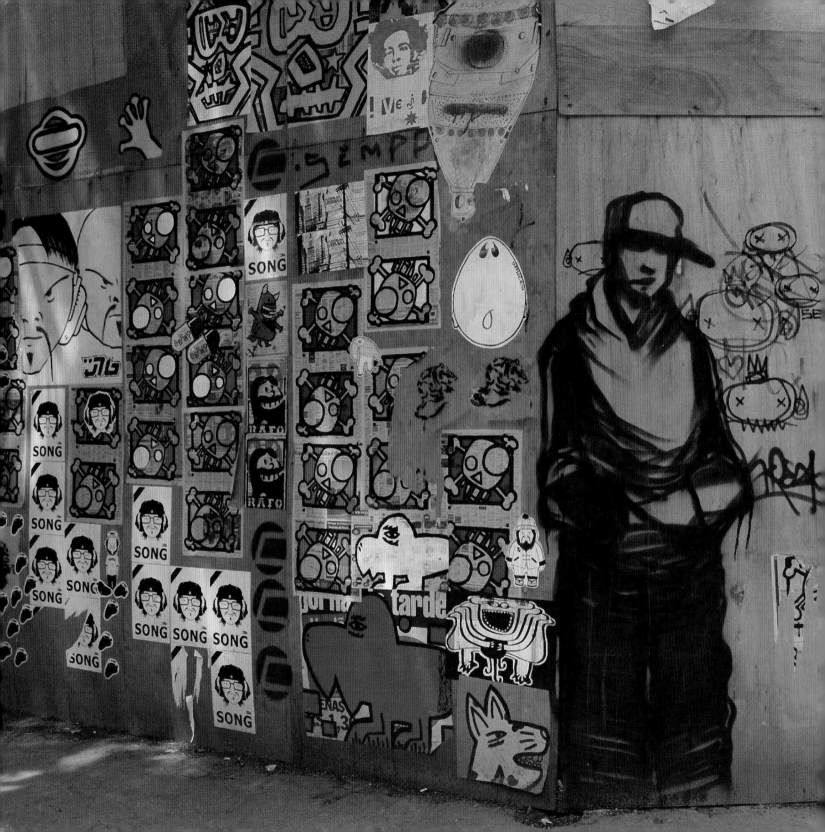

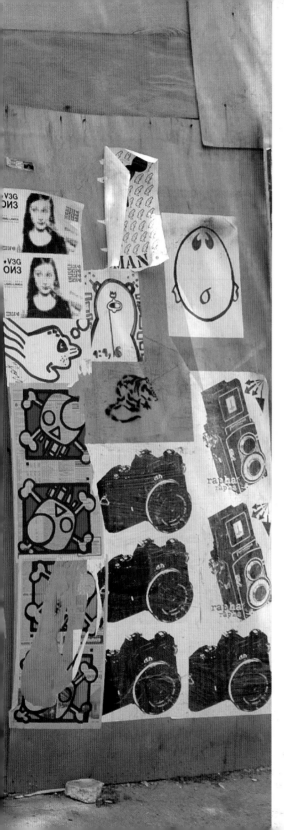

# Street Art (*Arte nas ruas*)

The street art scene is part of a global trend but, like all graffiti in Brazil, it has its own twist. Until recently the only posters seen on the street would be for gold sellers (*compro ouro*), concerts or perhaps missing people. This has now changed, with street artists posting up alternative signs, messages and drawings, to the amusement and bewilderment of the public. It has spread beyond São Paulo and Rio de Janeiro, with smaller cities such as Curitiba and Porto Alegre becoming particular hotspots. Street art may only represent a small percentage of Brazilian graffiti, but it has been capturing people's imagination and reviving a general interest in graffiti art.

For some street artists, the attraction lies in placing their art or message in the public domain without conforming to a particular graffiti style or ideology. Others feel that they have more in common with graffiti painters and see street art as part of the wider graffiti scene. In fact, years before the current street art boom, one of the first artists to produce hand-painted posters was actually a graffiti writer: Onesto. With the alias *você dice mais* (you say more), Onesto used single-coloured posters to explore the idea of silhouettes based on his characters.

Handcrafted techniques in poster and sticker production are what make Brazilian street art so vibrant. Computer graphics and photocopies are used to make posters and stickers, but the trend is towards hand-drawn and painted images.

Lacking the resources to make mass-produced stickers, artists instead recycle by painting over any unused ones they can find. Posters are often printed using silk-screen or woodblock on discarded materials, such as old newspapers, comics and telephone directories. Although it is partly an ecological choice to recycle, it also reflects the urban environment.

Acknowledging the connection between street art and found rubbish, a gallery in São Paulo, Choque Cultural, recently organized a show called 'Catalixo' (From the Trash). Artists were invited to produce work on rubbish skips, using found materials in an original way to celebrate the street.

Since street art posters are new to Brazil, the general public are often curious about these enigmatic images. What are these strange campaigns for? This is in contrast to New York or London, where the general public are beginning to recognize the work of street artists and their pseudo-campaigns.

Street art, like graffiti, is both a commentary on modern urban life and an outlet for expression. The current street art scene has resonances with concrete poetry, a Brazilian art movement that flourished during the 1950s and '60s and still exists today. It is a visual poetry that uses eccentric typography, collage and photographic montage and a playful approach to language. This hybrid of literature and art usually takes the form of a painting or drawing, but it has also been used in video and sculpture.

The word 'concrete' was a reference to modernity and modern architecture, and to the way in which this material can be formed into any shape. Street artists use the surface of the city to make their own artistic statements and in this way could be described as Brazil's new concrete poets.

Work by Jurubis, Marmita, Roninho, César, Rafo Castro, SHN, Mea, Titifreak, Rapha Chã and Rafo, São Paulo, 2004

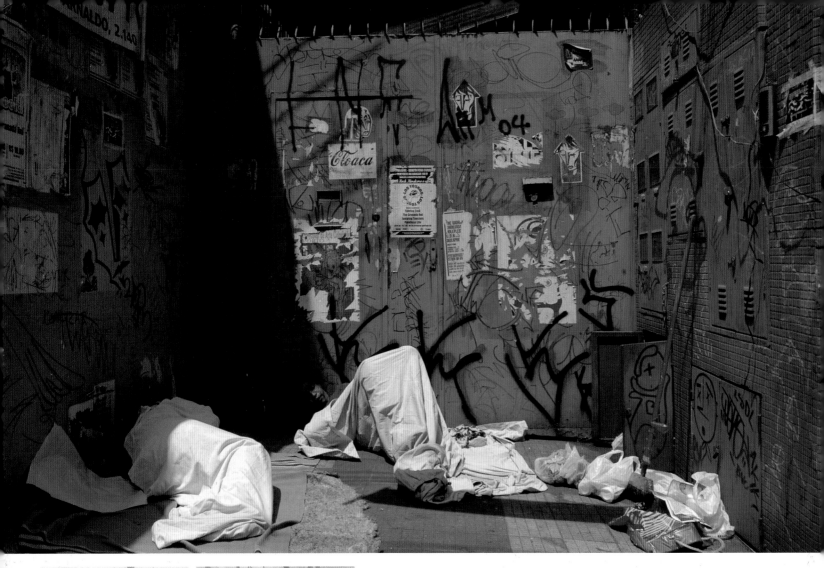

**Above** Posters by Calma and others, São Paulo **Bottom left** Rim painting
with roller, Curitiba, 2004 **Bottom right** Unknown artist, Curitiba, 2004

**Opposite**
**Top left** Lar Crew and Cimples, Curitiba **Top right** Trampo, Porto Alegre
**Second row, left** 9li, Porto Alegre **Second row, centre** Unknown artist,
Curitiba **Second row, right** Saints after Nossa Senhora Aparecida
by Maionaise, São Paulo **Third row, left** Jeyone in action at
the 'Catalixo' exhibition, Choque Cultural, São Paulo, 2005
**Third row, centre** Unknown artist, São Paulo **Bottom left** Fefe,
São Paulo, 2004 **Bottom right** Nina de Moraes, Porto Alegre, 2004

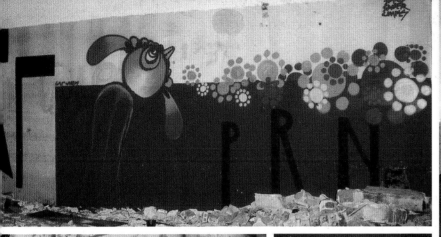

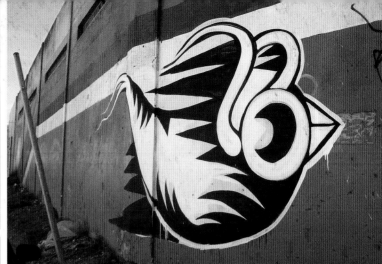

HUMAN BODY AS ART

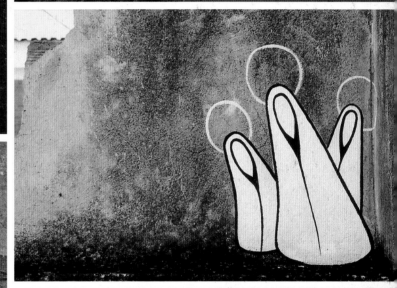

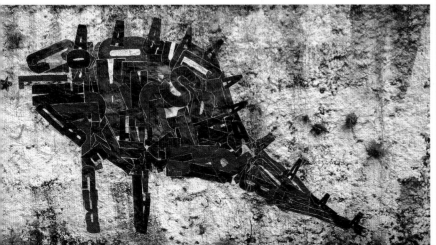

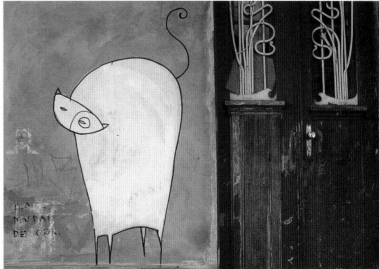

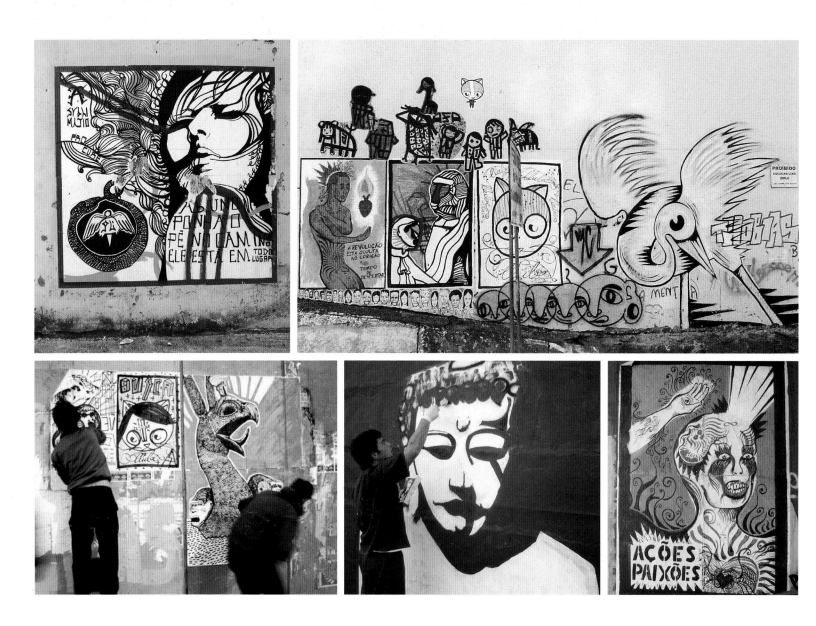

# Upgrade do Macaco

Fairy tales, religious imagery and the supernatural are just some of the inspirations behind Upgrade do Macaco's art. Upgrade do Macaco ('Upgrade the Monkey') is a collective of young artists from Porto Alegre, whose main motivation is to bring beauty and imagination to the streets. The results appear in their large hand-painted posters, stencils and mixed-media collages. They see street art as 'the fastest and cheapest way to communicate with people'. During elections, for example, they ran fake campaigns using their own characters and messages on electoral posters. The collective includes Pingarilho, Carla Barth, Tinico, Trampo, Pilla, Bruno, 9li and Gera – all prolific artists with their own styles. They collaborate on artwork both on and off the street and act as a network to encourage each other's talents. Like alchemy, another one of their obsessions, they believe that by fusing their ideas together they can produce magical, unexpected results.

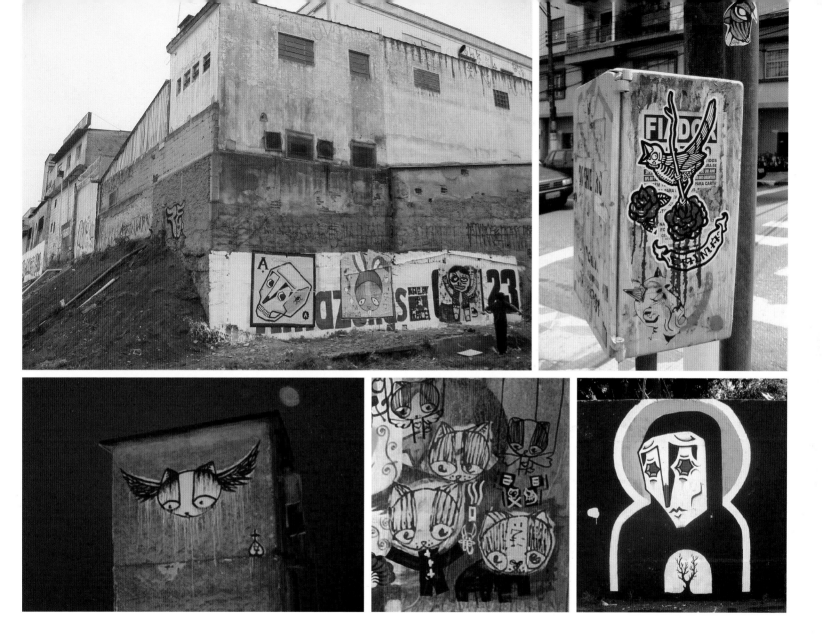

# Faca Crew

Faca (meaning 'knife') brings together friends from two cities: Tinico, a tattoo artist and painter from Porto Alegre, Calma, the alter ego of Stephan Doitschinoff, an up-and-coming illustrator from São Paulo, and finally Asa, otherwise known as Carlos, a musician in two independent rocks bands – Againe and Polara. As individual artists and as a team, Faca have kept up a campaign of intriguing images in both cities with stickers, posters and sometimes large-scale paintings.

Tinico is best known for his humorous cat characters, painted with a flourish. Calma is now recognized worldwide for his bold figurative images that show some influence of *cordel* literature. Earlier woodcut art from the Middle Ages and from the Mexican tradition are also referenced in his use of skulls and scrolled epitaphs in his compositions. Asa's work has a naive style that features animals and figures vigorously painted with marker pens and brush.

**Above** Denys and Sino, Itaquera, São Paulo
**Left, from left to right** Unknown artist, Curitiba, 2004; Plim, Porto Alegre, 2004; Tony de Marco and others, São Paulo, 2004

**Opposite**
**Top left** Nunca, São Paulo, 2004
**Centre left** Gordo and SHN, São Paulo, 2004 **Centre right** Cimples, Curitiba, 2004
**Bottom left** Posters by Jeyone, Boleta and others, with pen drawing by Titifreak, São Paulo, 2004 **Bottom right** Yellow Dog
**Right** Posters by Rafo, with sticker by Yellow Dog, Rio de Janeiro, 2004

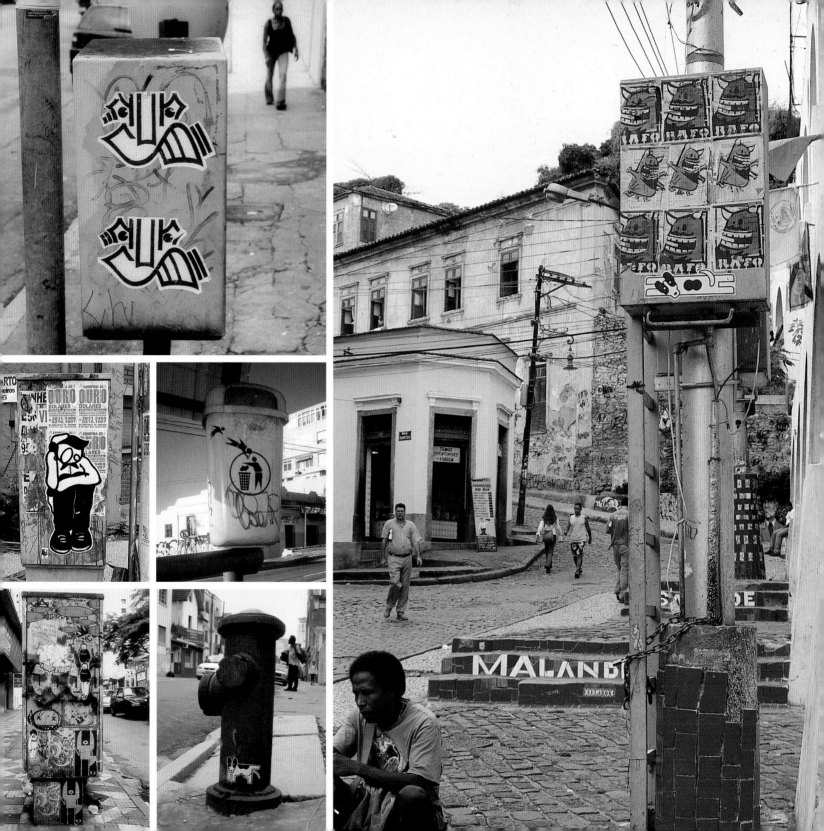

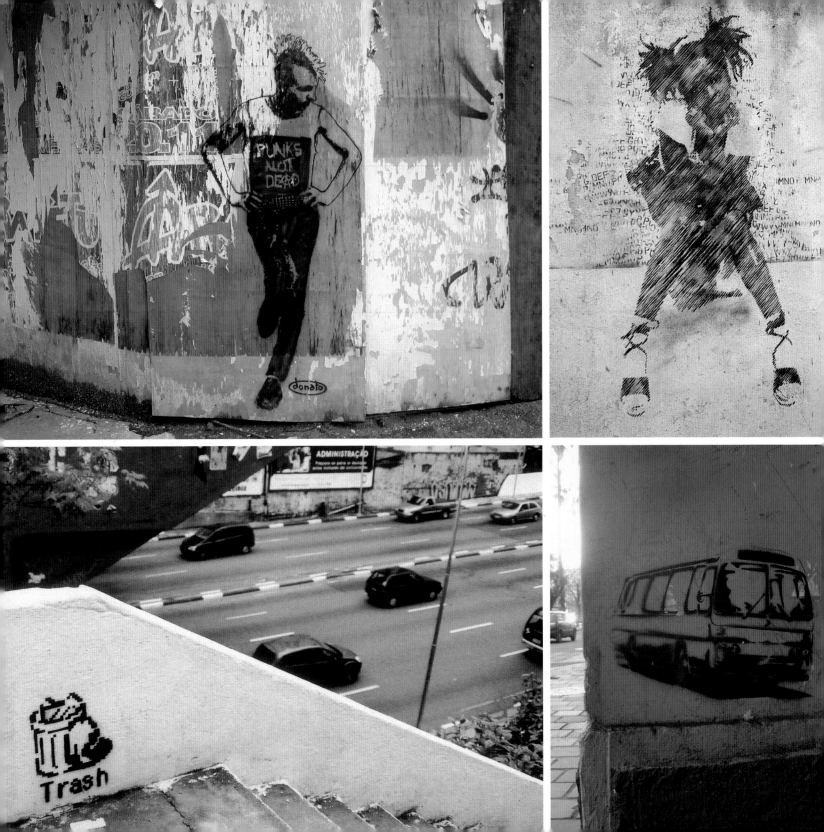

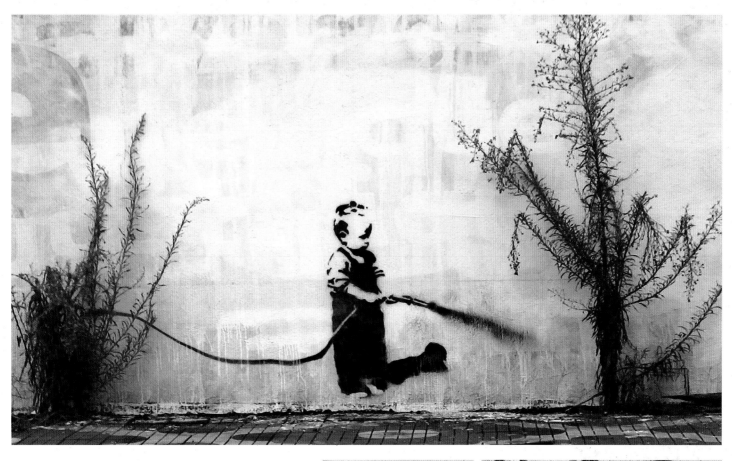

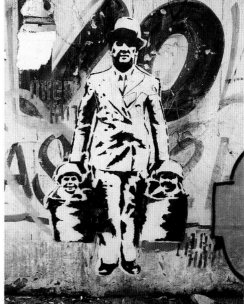

**Opposite**
**Top left** Donato, São Paulo, 2004 **Top right** Unknown
artist, São Paulo, 2004 **Bottom left** Unknown artist,
São Paulo, 2004 **Bottom right** Kaleb, São Paulo, 2005

**Above** Kaleb, São Paulo, 2005 **Right, clockwise
from top left** Unknown artist, *Meu amor* (My Love),
São Paulo, 2004; Daniel Melim; Daniel Melim, São
Paulo, 2004

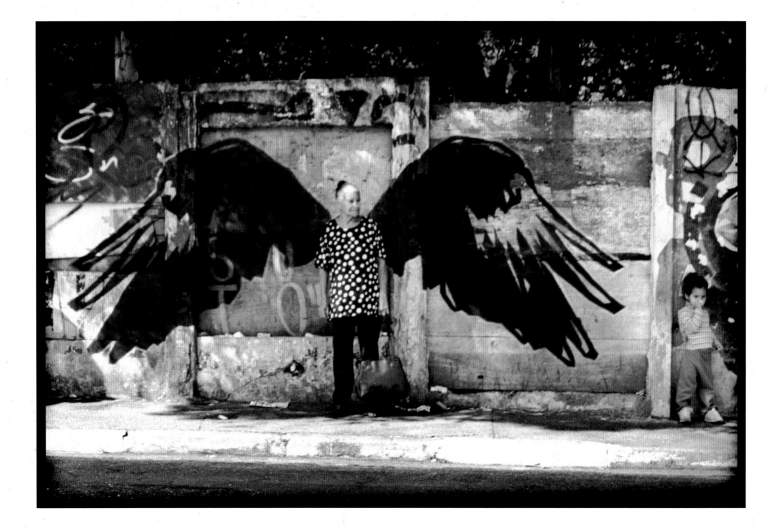

# Alexandre Órion

Alexandre Órion's work unites photography and graffiti. His stencils demonstrate a wonderful sense of humour and ingenuity, but it is his photographs that are his final artistic statement. To him, it is vital that his painting interacts with city life. He often spends days or even months waiting to capture a perfect moment of synchronicity. Sometimes it is a reaction to his images from a member of the public, but often it is an accidental occurrence or a poetic association.

The lives of the poor and homeless are often the focus of his photographs, and his stencils create a theatre in which they play a part. These snapshots celebrate the everyday endeavours of ordinary citizens by creating moments of magic that portray them in an extraordinary light. In these brief moments, the outstretched wings of an angel embrace a shopper resting in the shade, and a stencilled horse echoes the toil of a man pulling a cart. Órion's paintings are inventively staged, but the beauty lies in the unplanned instances that can turn an ordinary streetscape into a work of art.

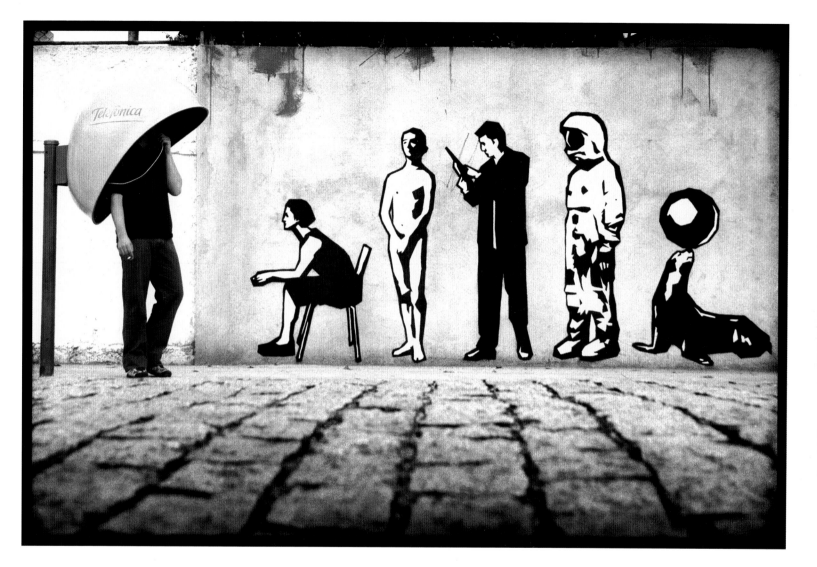

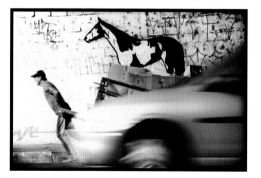
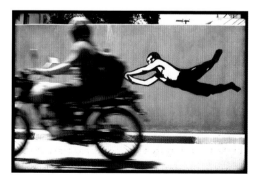
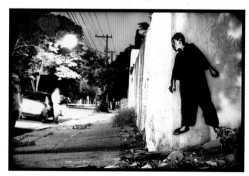

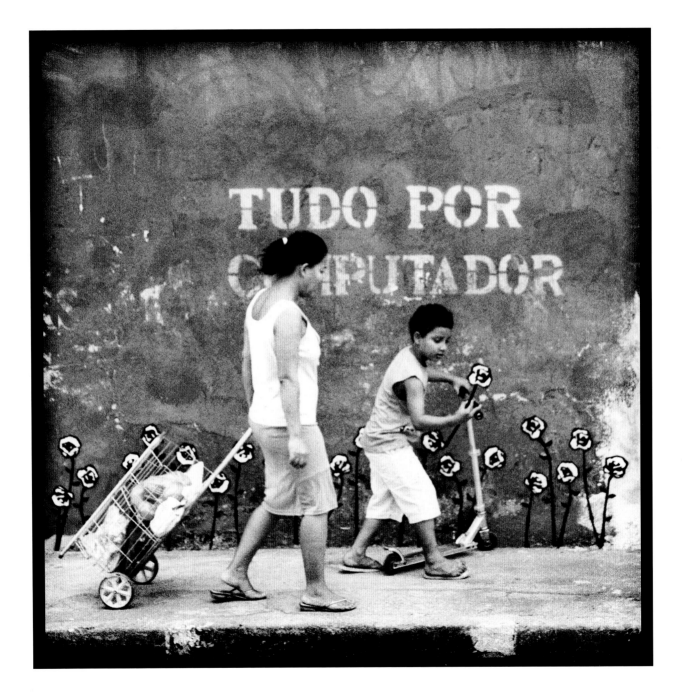

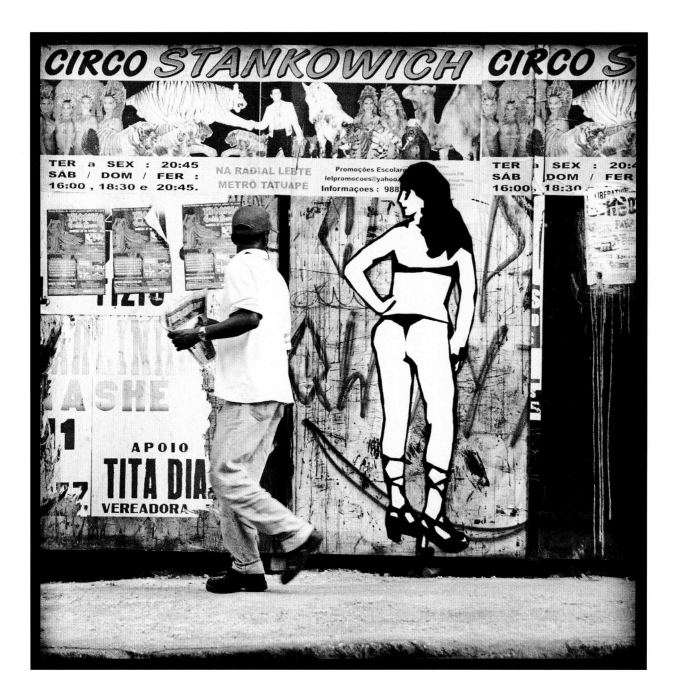

# Glossary

*Agenda* Wall covered in *pichação*

*Antropofagia* Literally 'cannibalism', a Brazilian cultural movement that encouraged the use of foreign culture, satirizing its less useful aspects

*Arco-iris* Literally 'rainbow', a *pichação* tag that arcs, usually over a window

*Atropelar* Literally 'to run over', as with a car, appropriated in graffiti to mean painting over someone else's work

*Cara dura* Literally 'hard head', doing something out in the open without fear of reprisal, such as painting in a risky/illegal spot in broad daylight

*Carioca* A person from Rio de Janeiro

*Com rolo e cabo* A technique used in *pichação*, employing a roller and extension pole to reach down off the edge of a building or high up from the ground

*Embalo* What graffiti writers elsewhere call a 'spot jock', the guy who comes along and paints something right next to you after you've been the first to paint a fresh spot. Not cool!

*Favela* Shanty town

*Favelados* Person living in a *favela*

*Grafite* Literally 'graffiti', but this term is not in common usage in Brazil

*Grapixo* Hybrid lettering style combining graffiti and *pichação*

*Grife* A multi-crew symbol. Often *pichação* crews write their crew names next to their own names. A *grife* symbol is made by a conglomeration of crews

*Ibope* Quick, cheap fame

*Lambe-lambe* Literally 'lick-lick' – posting handbills

*Latex* Water-based acrylic house paint

*Legal* Literally 'legal', used in Brazil in exactly the same way as the English word 'cool'

*Literatura de cordel* Literally 'string literature', a folk literature combining woodblock prints and verse fables in zine format, from the Brazilian northeast

*Painel* Literally 'panel', used to describe a large and detailed graffiti mural. What most graffiti writers elsewhere would call a 'production'

*Paulista* A person from São Paulo

*Pichação* Pronounced 'pee-shah-sow', a graffiti style endemic to Brazil, often spelt *pixação* on the street

*Pixo contornado* Pichação with outlines. What *pichação* writers call *grapixo*

*Rolê* Literally 'roll', taking a day to paint in the streets

*Sopa de letrinhas* Literally 'alphabet soup', a wall covered in throwups, one above or to the side of another, without obscuring any

*Turma* Crew

*Zona (da cidade)* City quarter or group of neighbourhoods

**Left, from top to bottom** *Rolê*, São Paulo, 2004; Nação Crew bicycle; *pichação* lettering; latex paint and roller
**Opposite, from top to bottom** Nunca and Nina, São Paulo, 2004; Os Gemeos and Onesto, São Paulo, 2004; Tinho and others; Binho

# Bibliography

Andrade, Oswald de, *Obras Completas de Oswald de Andrade* (Editora Globo, São Paulo, 1991)

Costa, Nando, Miguel Vasquez/MASA and R. Klanten (ed.), *Brasil Inspired* (Die Gestalten Verlag, 2003)

Frantik 179 and Ignacio Aronovich, 'Double Trouble', *Graphotism*, Issue 32

Gitahy, Celso, *O que é graffiti* (Editora Brasiliense, 1999)

Levine, Robert M., and John J. Crocitti (eds), *The Brazil Reader: History, Culture, Politics* (Duke University Press, Durham, 1999)

Neelon, Caleb, 'Brazil', *12 Oz Prophet*, Issue 6, 1998

Neelon, Caleb, 'Brazil Diary', *Brain Damage*, Issue 7, 2002

Neelon, Caleb, 'São Paulo: Hidden City', *Swindle*, Issue 1, 2004

Page, Joseph A., *The Brazilians* (Addison-Wesley, Reading, Mass., 1995)

Scavone, Marcio, *A cidade ilustrada* (Alice Publishing editora, 2004)

Schlecht, Neil E., 'Resistance and Appropriation in Brazil: How the Media and Official Culture Institutionalized São Paulo's grafite' in *Studies in Latin American Popular Culture*, Vol. 14, 1995

Skidmore, Thomas E., *Brazil: Five Centuries of Change* (Oxford University Press, Oxford, 1999)

Veloso, Caetano, and Barbara Einzig (ed.), *Tropical Truth: A Story of Music and Revolution in Brazil* (Bloomsbury, London, 2003)

# Websites

www.theartwheredreamscometrue.com

www.lost.art.br

www.graffitibrasil.com

www.artbr.com.br

# Picture Credits

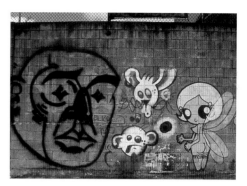

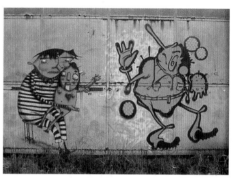

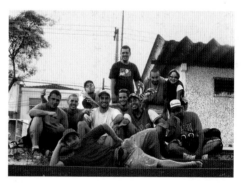

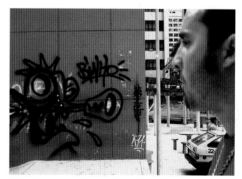

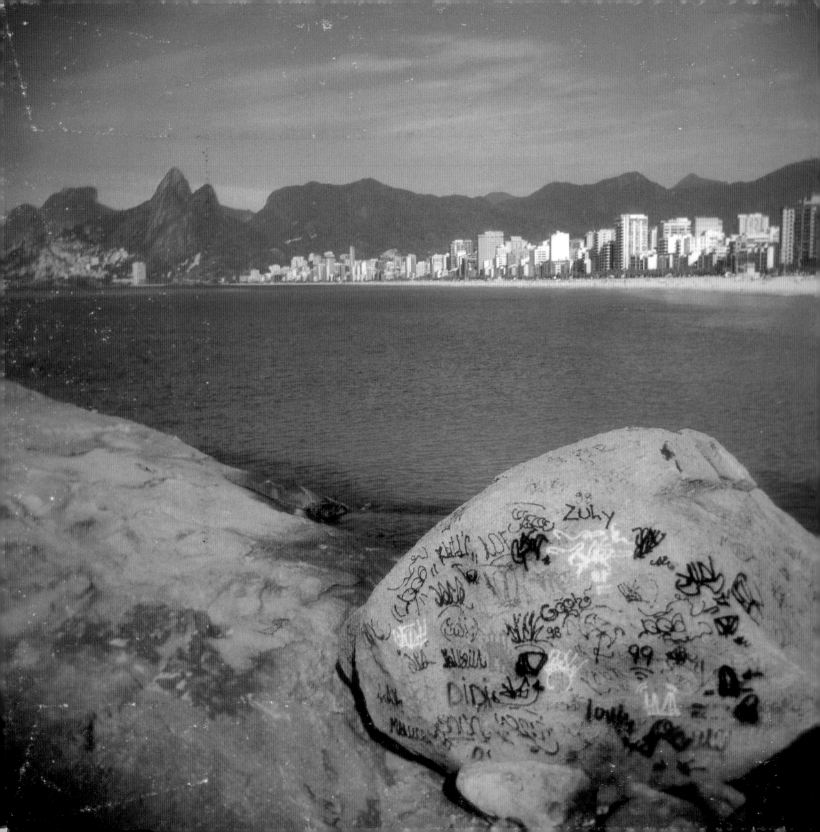